BELL COUNTY

KENTUCKY

BELL COUNTY

KENTUCKY

A BRIEF HISTORY

TIM CORNETT

Charleston · London

THE
History
PRESS

Published by The History Press
Charleston, SC 29403
www.historypress.net

Copyright © 2009 by Tim Cornett
All rights reserved

Front cover image, top, and back cover image, bottom, by Jimbo Helton.

First published 2009

Manufactured in the United States

ISBN 978.1.59629.809.5

Library of Congress CIP data applied for.

To Becky…and "dancing on the front porch."

CONTENTS

CONTENTS

FOREWORD

I first met Tim Cornett when he was a senior at Pineville High School and I was a rookie history teacher. He came to my attention because I noticed him each day in the halls during my afternoon planning period. I found that he had unofficially shortened his school day and routinely skipped his last-period study hall. He explained with a straight face that he had important work to do at home. Since that rocky introduction, Tim has consistently been involved in "important work." However, making a living has generally been an interference. He has been a newspaper reporter, a newspaper editor, a public relations director, a magazine editor and numerous other minor vocations. However, his serious work since those high school days has consistently been a continuing inquiry into the history of Bell County.

The Cumberland Gap area is home to one of the most historically significant regions of the West, and Tim Cornett has endeavored to investigate Bell County's role. He has researched extensively in secondary sources, but probably any competent researcher could have done the same. However, only someone who knows Bell County and its inhabitants intimately could have conducted the interviews and been given access to primary sources that have gone into this work. These interviews have been conducted not during a short period of time but over half a lifetime. Many of these sources have died and others have left the area. Because of his "important work," these characters from Bell County's past can continue to be heard.

Thomas Kelemen
Pineville, Kentucky
September 2005

INTRODUCTION

B ell County is a place of history.
Long touted as the "Gateway to the West" is the Cumberland Gap in…Bell County. Known to every schoolboy is Daniel Boone, who first entered Kentucky by way of…Bell County. Forever revered as the path of the pioneers is the Wilderness Road, which begins in Kentucky, in…Bell County.

Bell County's story lies in the lives of the countless thousands who have made their homes here, who have eked a living out of the rocky soil, who have survived booms and busts as the fortunes of a black mineral called coal have fluctuated on the world market.

But for the works of Judge William A. Ayers and H.H. Fuson, little has been written about the full scope of the history of Bell County—the last of these almost seventy years ago. Both works have their merits, but nothing was written that came from the everyday Bell Countians' lives.

In this volume I have attempted to do that. Included are materials drawn from letters, privately printed memoirs and personal interviews that will show the story of the men and women who made up Bell County.

This book does not pretend to be a complete history or an "up-to-date" history; both of those are misnomers. The best chroniclers of complete histories are the daily and weekly newspapers, but they too come short for they can report on only what is learned at the time and not on the actions behind the scenes.

Readers will note that this volume is bare of footnotes. I realize that most books of this ilk are usually very heavily footnoted, but I personally don't like footnotes—they distract one from the text. With that in mind, I have given credit in the main text wherever it was necessary and have also included a fairly extensive bibliography.

History is very much like biography—the biography of a place rather than a person—and in a biography, one must include things that some readers would rather see omitted. To those readers I offer these words: in a true biography all things must be used, the bad as well as the good.

I wish here to thank those who have been patient with me during twenty-five-plus years of research, who listened patiently to my questions and even more patiently when—my questions answered—I rambled on about what I had found. Thanks also to those who have allowed me to interview them or who have just "talked history" with me; thanks to those whose work I have used in my research. Thanks to Dr. Billy T. Dye for the "old beige"; I couldn't have made it without it. Thanks also to Ron Day for making the required "cuts" in what was originally a very lengthy manuscript.

EARLY RESIDENTS

Long before settlers from Virginia and North Carolina made their way into the land of Kentucky in a westward push of expansion, there was myriad life and movement in and out of the area. Known to the Cherokee, the Shawnee and, occasionally, the Seminole, the mountainous terrain that was to eventually become the Gateway to the West was used mostly as a hunting ground and as a path for war parties to and from the southern and northern sections of the country.

Eons ago, when the first deep rumblings in the earth began to form the mountains we have come to call the Cumberland and Pine Mountain Ranges, there was wildlife in abundance in what is now Bell County, Kentucky. The area teemed with game—large and small—making it a natural hunting spot for those races of men who were to follow.

It is known that a pre-Mississippian and a Mississippian society flourished in the area; when Dr. Walker ventured into the Cumberland Gap area in the 1700s, he found traces of these people. Yet, by the time of mass immigration into "Kaintuck," virtually all signs of these people had vanished—ravaged by time, the elements and civilization.

Several years ago, Dr. James S. Golden Jr. of Pineville told an interesting story of the discovery of skeletons on the mountain just outside of Pineville. According to Golden, a local hunter stopped to rest just before dawn. Sitting down on what he thought was a pile of brush and branches at the bottom of a tree, the hunter discovered that he was seated on a pile of what looked to be human bones.

These bones were taken to Golden, who was able to assemble four almost complete skeletons—complete except for the skulls. Golden said that the skeletons appeared to be from a race of people who were "short and stocky.

Artist's view of the Yellow Creek Valley from Cumberland Gap, circa 1888. This is much the way the area would have appeared to Dr. Thomas Walker when he first entered Kentucky. *From* The Bell County Story: The Unfolding of a Century.

The femurs were twice the diameter of a modern man's, and shorter." He estimated that the people would have weighed between two and three hundred pounds, based on their skeletal structure.

Without the skulls there was no way of determining more about these people. Theorizing that the bones had come from some ancient burial site on Pine Mountain, Golden, the hunter and others scoured the mountainside for more bones and, hopefully, the skulls. Dr. Golden's best theory was that the bones had washed out of their resting place during heavy rains over many years and lodged against the tree where they were found. He guessed that the skulls, being round, would have rolled on down the mountainside and possibly entered the Cumberland River just south of Pineville, where U.S. 119 meets U.S. 25E.

The skulls were never located, and Golden, unable to glean any more information from the skeletons, sent them on to the Smithsonian Institution, where presumably they rest today. (Efforts by the author to locate these skeletons have been unsuccessful; Golden forwarded them to the museum, but calls to the Smithsonian have proved fruitless in finding their exact whereabouts.)

Kentucky and Bell County have proven to be a mixed bag for historians. We know that the area was used for hunting by various tribes of Native Americans. We know that the earliest visitors to the area found traces of early civilizations. We know that Dr. Walker, Daniel Boone and others had a vested interest in seeing the land opened to exploration. All of this we know from the traditional history books and documents that have been touted and rehashed for more than two centuries.

But what do we know of the people—the common man who faced the hardship of travel along what eventually became the Wilderness Road? It was these hardy men, women and children who—having left the relative comfort of their homes in settlements in Virginia, North Carolina, Pennsylvania and other states—came into the wilderness of the new land of Kentucky to seek their own way of life that make up our history.

In the pages to come, we will take a look at the early ventures into what eventually became Bell County and at the settlers and civilization that followed. These hardy souls settled a wild frontier and they are our legacy; they are our history.

1750 First in Ky (handwritten annotation)

CHAPTER 2

WALKER ENTERS KENTUCKY

One of the earliest recorded entries into Bell County was by Dr. Thomas Walker, a Virginia physician employed by the Loyal Land Company to locate a place for a settlement in Kentucky, which at that time was a county of the Commonwealth of Virginia.

The Loyal Land Company had a grant of 800,000 acres of land north of the border between Virginia and North Carolina, the area that now encompasses Kentucky, and it hired Dr. Walker to take a party into this uncharted territory to scout for suitable places for establishing settlements and to survey the land. Walker was chosen by the Loyal Land Company for his skill as a surveyor and his penchant for exploring some of the other rugged terrain throughout the area. He had, in 1748, made a similar expedition through southwest Virginia into the Cherokee lands near the Holston River that played a large role in the white settlement of this area. *Harley Land*

Because of this, Walker was contracted to explore Kentucky. In March 1750, Walker set off from his home in Virginia in the company of Ambrose Powell, Colby Shew, William Tomilson, Henry Lawless and John Hughs. Each man was outfitted with a horse and there were two extra that served as pack animals.

From March 6 through April 12, Walker and his companions made their way through southwest Virginia and into the Holston Valley of Tennessee. By April 13, they had arrived at the site of what would later be one of the most significant locations in the opening of the West. At the time, to them, it was just a gap in a formidable mountain range, allowing fairly easy passage into Kentucky.

A look at the journal Walker kept reveals his thoughts on crossing the gap into Kentucky:

> *On the North side of the Gap is a large Spring, which falls very fast and just above the Spring is a small Entrance to a Large Cave, which the Spring runs through…On the South side is a plain Indian Road…This Gap may be seen at a considerable distance, and there is no other, that I know of, except one about two miles to the North of it, which does not appear to be So low as the other. The Mountain on the North Side of the Gap is very Steep and Rocky, but on the South side it is not So.*

Walker's journal reveals that the party traveled across the gap into what they named Flat Creek, the area we now call Yellow Creek, where they camped along the banks of the creek. This area would later become the city of Middlesborough. His journal notes the fact that he found coal along the creek bank, significant because mining would become a major industry in the area and the reason for many future "booms and busts."

The next day the party traveled another five miles down the creek, following the Indian Road. The following day was Easter Sunday, April 15, 1750. Walker and his party normally did not travel on the Sabbath, but on this occasion they traveled farther downstream to find a more suitable campsite for their horses. They covered seven more miles along the Indian Road, coming to what Walker named Clover Creek.

This creek we now know as Clear Creek, situated near where the Cumberland River breaks through the Pine Mountain range at Wasioto Gap. Walker and his party camped on the site of what is now Wasioto Winds Golf Course on a small knoll known locally as Devil's Backbone. For the next two days they remained at this campsite, rains delaying their journey.

On Tuesday, April 17, still delayed by rain, Walker explored the area around Clover (Clear) Creek. He went down the creek hunting and discovered that the creek emptied into a river about a mile below his campsite. Deciding that this river was created by other creeks in the area, he noted, "This, which is Flat [Yellow] Creek and Some others join'd, I called Cumberland River."

Walker named the river after the Duke of Cumberland, not knowing that the Indians called it the Shawnee River, after the last permanent Native American residents of the area. Walker chose to honor the "Bloody Duke," considered a national hero due to his recent victory at Culloden. Later, hunters would give the name of Cumberland to the great mountain range that Walker had crossed to enter into Kentucky.

April 18 dawned cloudy but without rain, so Walker's party moved on, traveling down the creek to the river and along the Indian Road to where it crossed the river. This crossing was made at the present-day site of Pineville,

This photo, claimed to be the first taken of the Cumberland Ford, shows the river crossing at Pineville, Kentucky. *From* The Bell County Story: The Unfolding of a Century.

just across the river from the intersection of Pine Street and U.S. 25E. This (the Cumberland Ford) and the Cumberland Gap are two of the most significant natural occurrences along the Wilderness Road, enabling travel into the frontier.

Walker notes in his journal that "Indians have lived about this Ford Some years ago." This observation was no doubt based on the nearby "Indian Burial Mound," which was a prominent site in Pineville until the 1970s, when it was razed to make way for a commercial building.

After crossing the river at the ford, Walker's party trekked along the south side of the river for about five miles. Due to rough terrain and some unfordable streams, they left the river and headed across country for about three miles, when they again came upon the river, it being very crooked and crossing back along their path. They camped that night after having covered about eight miles, which put them into what is now Knox County.

The burial mound noted by Walker again played a role in early development of the area twelve years after Walker's sighting. James

Renfro, an early explorer of Kentucky and later a prominent citizen of the settlement of Cumberland Ford, noted that when he was exploring in 1762 he was forced to conceal himself from "savages." He hid in cliffs along Breastwork Hill, opposite what is now Pineville, and from this vantage point he witnessed an Indian battle. He also saw the Indians carrying stones to construct a mound.

This mound was disturbed several times over the years as white men settled the area. The first disturbance came when Dr. William J. Hodge built a house on the site about 1890. Eighty years later, in 1970, the house was torn down and the mound razed to erect a building supply house.

At this time, the mound was studied by the University of Kentucky Anthropology Department. This study supports Dr. Walker's statement that Indians had lived there "some years ago" and Renfro's observation of construction of the mound some twelve years later. The report states that the mound was built in two stages, with the first stage being a flat-topped structure three to four feet in height. The second structure was built soon after the first, as pottery shards found in both sections came from the same period and there was a definite demarcation between the two sections of a band of orange-colored burnt earth. Other shards of pottery found in the first section of the mound help to date early Indian movement in the area at 800 to 1200 CE. The tribal group itself was not determined.

We will take another look at this mound later in this narrative, as some of the burials made there played a role in another part of our history—the period of the War Between the States, when the mound was used for some battle casualty burials.

WALDEN, FINLEY AND BOONE

Following Walker's foray into Kentucky, there were others who wished to explore the lush hunting grounds. One of those was Elisha Walden. Walden's origins are not known; he comes to us in the time of the Indian uprisings on the frontier and is described as "dark-skinned, squarely-built and rough featured," a typical frontiersman more interested in hunting the abundant game available in Kentucky than in establishing a settlement there.

In 1761, Walden assembled a group for a major hunt in the wilderness of Kentucky. It included William and Jack Blevins, his father-in-law and brother-in-law; Henry Skaggs; Charles Cox; Walter Newman; and several others trained in the ways of the woods. This hunt proved so successful that Walden and his men stayed away for eighteen months, exploring the southwest territory leading into Kentucky. They hunted from the wild region of the Holston River in Tennessee to the Cumberland Gap, crossing and re-crossing the Warrior's Path many times.

During their hunt, they gave names to many of the places familiar to us today—Newman's Ridge, Walden's Ridge and Powell River. During Walker's exploration he had given the name Beargrass River to what we now call Powell, but during Walden's hunt, his men found the initials "A. Powell" carved on so many trees around the river that they gave it Powell's name.

Crossing the mountain into Kentucky, Walden's party strayed from the well-worn Indian trail and ventured north along the Cumberland River, giving names to some of the creeks. One such creek was named Wallins, a variant spelling of Walden.

The 1761 expedition proved successful, producing an abundance of rich furs to be sold when the travelers returned home. It was so successful that

Crossing the ford. Pioneers cross the Cumberland River ford in their trek westward. During the years of westward expansion, over 400,000 people waded the ford, now the location of Pineville, Kentucky. *Sketch by Robert Mason Combs. Used by permission of the Combs estate.*

Walden organized another long hunt in 1763, taking with him the same group of skilled frontiersmen. Following the old trail through Cumberland Gap, which he and his group had renamed from Walker's Cave Gap on their first hunt, Walden hunted extensively in the southeast area, centering much of his activity in what would become Bell County. He also ventured into what is now Knox County, hunting and trapping along Stinking Creek and as far north as Crab Orchard.

As the news of Walden's hunts spread throughout the Yadkin Valley of North Carolina and Rockbridge County, Virginia, more frontiersmen took up the challenge of hunts in Kentucky. By 1769, the time was ripe for the frontiersman who has come to epitomize Kentucky and the opening of the West to stride upon the scene.

John Finley of Pennsylvania was in the Yadkin Valley peddling housewares during the spring of 1769. There he met up with his old friend and fellow soldier from Braddock's army, Daniel Boone, and filled him with visions of the beautiful meadowlands in Kentucky and of the

abundant game just waiting for a hunt. Boone proposed that they organize a hunt and persuaded John Stuart, his brother-in-law, to join them. They also recruited James Mooney, William Cooley and Joseph Holden as camp helpers. By May 1, 1769, all was ready, and the party of hunters left the Yadkin to journey to Kentucky.

Finley had told Boone that there was a "big gap" in the mountain range that had been used as a passageway by the Indians for untold years. Boone, familiar with the southwestern area of Virginia, knew of the trail leading to this gap. The stage was set, and Boone and his party were soon to step not only into the wilds of Kentucky but also into the pages of history.

By the fall of 1769, the party came into Powell Valley at the southern base of the Cumberland Mountains. Journeying down the valley through dense thickets of timber and brush, fording small streams and climbing small hills, Boone and his party made their way to the V-shaped dip in the mountain that Walker had discovered almost two decades earlier.

In the saddle of this gap, the party crossed into Kentucky along the Warrior's Path that Walker had taken. They crossed the Yellow Creek Valley

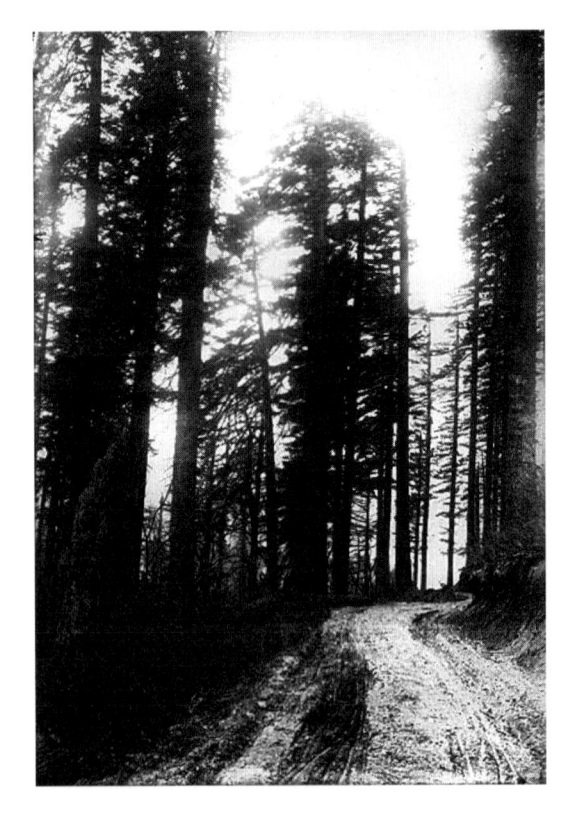

This early 1900s view of the road leading up Cumberland Mountain to the gap from the northern side of the mountain shows a roadway much unchanged since it was first carved out of the wilderness by Daniel Boone. *Author's collection.*

and made their way on to the ford in the Cumberland River south of Wasioto Gap. The party did not tarry long in the area of the ford but made their way to Flat Lick in the Knox County area. This salt lick was a favorite Indian campsite and a source of salt for the Native Americans.

Boone's party continued their hunt for several months, with part of the group eventually returning to the Yadkin, leaving Daniel and his brother, Squire, who had followed the party into Kentucky and caught up with them after a camp was established, to hunt alone through the winter of 1770–71.

Daniel and Squire finally returned to the Yadkin in the summer of 1771, but Daniel remained afire with the memories of the hunt in Kentucky. He was determined to move to this wilderness, so he sold the family farm and moved to Tennessee's Holston Valley in preparation for the move into the new land.

In September 1773, Boone gathered a party of forty to journey into Kentucky to found a settlement. Tragedy marked the expedition from the beginning. Two weeks after the journey began, a small party was sent back to procure flour for the rest of the group. As they camped by the side of the old Warrior's Path, they heard wolves howling close to the camp, and then, as the dawn broke, they were attacked by a band of Shawnee who showered them with arrows from all sides. Most of the group was killed outright, but Boone's son, James, and a Negro slave named Charles were taken prisoner and tortured to death.

Learning of the party's fate, the group of settlers buried the dead and held a council to determine their own course. Over Boone's protests, they opted to abandon the expedition. Boone was still determined to settle in Kentucky, however, and made another trip to the area in 1774, at the request of Virginia governor Lord Dunsmore, to warn surveyors of Indian attacks.

In 1775, the Transylvania Holding Company, through the efforts of Boone, was granted a vast area of the wilderness, and Richard Henderson, organizer of the company, hired Boone for a very important task—making a road into the wild and unsettled land.

THE WILDERNESS ROAD

With the decision of the Transylvania Holding Company to cut a road into Kentucky, the development of what would finally become Bell County was begun.

With a crew of thirty axemen, Daniel Boone began the formidable task of widening the centuries-old Warrior's Path from the Cumberland Gap to Fort Boone on the Kentucky River, an area that extended from one end of the land company's holdings to the other. Boone and his men made great progress through the canebrakes of the Yellow Creek Valley and along the twelve miles of trail that led to the Cumberland Ford; the road was easily marked and cleared owing to countless tramplings by hooves of migrating buffalo.

In the years that followed, Boone's Road, or the Wilderness Road, came to be the main thoroughfare for settlers moving into the frontier west of the Cumberland Mountains and beyond. With the opening of the road and the movement of settlers came statehood for the nation's fifteenth state.

One of Governor Isaac Shelby's first considerations after being sworn in as chief executive of the new commonwealth in 1792 was the improvement of the old Wilderness Road, the state's link with the eastern states. During the intervening years from Boone's widening of the trace in 1775 and statehood, over seventy thousand people had flooded into Kentucky along the road, and Shelby was well aware that it would continue to be a major artery to the West and must be maintained to accommodate the thousands more settlers to follow.

With no state funds for road improvements, Shelby turned to friends and neighbors for aid. The governor himself contributed three pounds to the road fund and convinced four others to match his gift. Eventually, 116

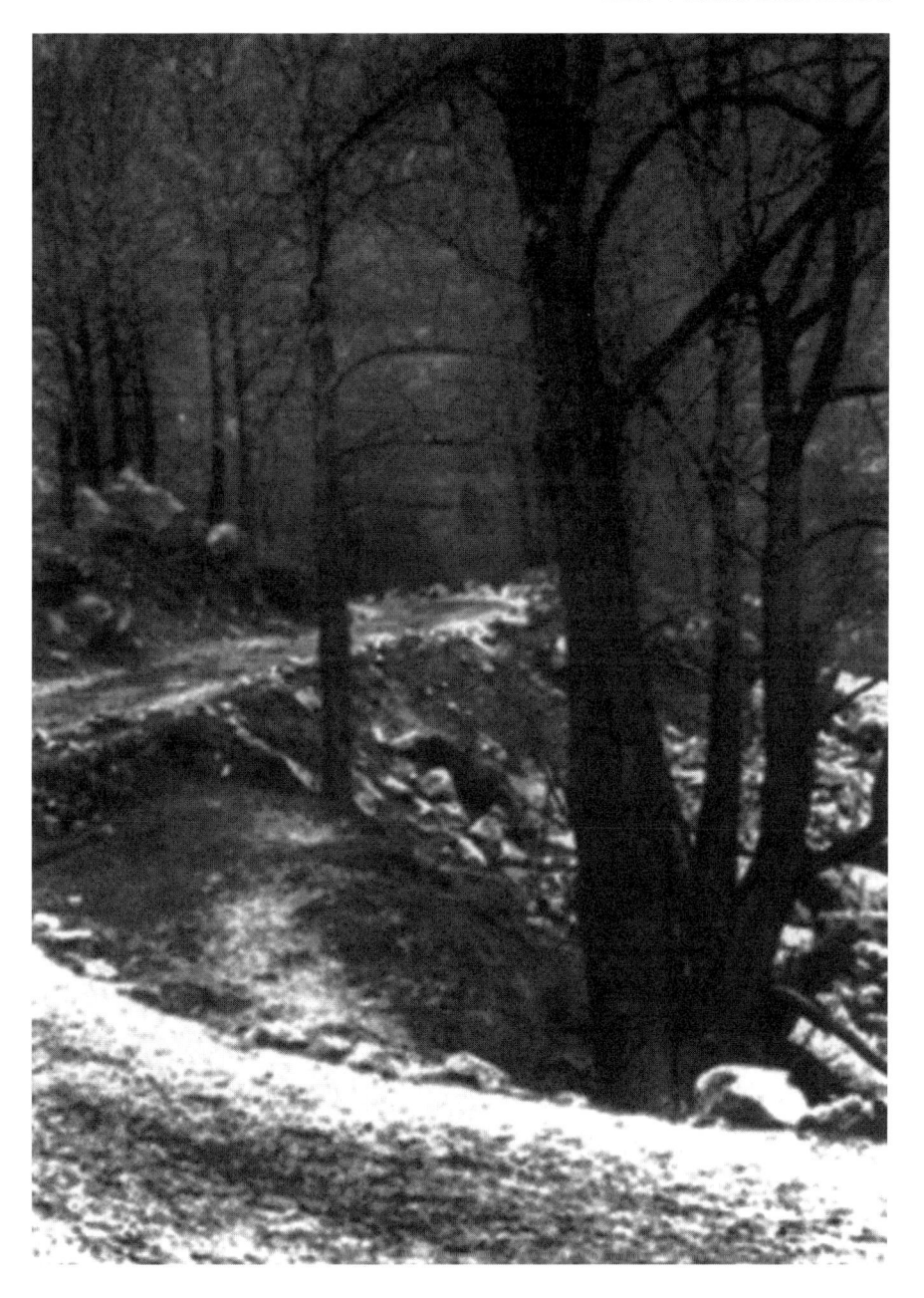

This 1907 view of the Wilderness Road through the Narrows near Pineville, Kentucky, shows a roadway much unchanged since the days of Daniel Boone. *Author's collection.*

additional persons contributed to the fund, and Colonel John Logan and Colonel James Knox were commissioned to supervise the road work. For a period of twenty-two days the work crews toiled along the old trail, widening it, trimming brush and creating a shorter route from Cumberland Gap to Crab Orchard. Although the improvements were not major in scope, the old trail did look more like a road when the crews finished.

Throughout Shelby's term as governor, the condition of the road remained in his thoughts, and as his stint as chief executive came to an end he sponsored major legislation to further improve the road. With the passage by the state legislature of "An Act Opening a Wagon Road to Cumberland Gap," Shelby's efforts to improve the road began in earnest.

Shelby commissioned Colonel Joseph Crockett and Colonel James Knox to make improvements to the road, following the provision of the act that it create safe and easy passage of wagons carrying up to one ton of weight. The road was mandated to be at least thirty feet wide, and when finished, it could not be changed by any private citizens or local governments without permission of the state legislature. A budget of £2,000 was appropriated for the completion of the task. The road was to commence at Crab Orchard and terminate in the gap at the top of Cumberland Mountain.

Crockett and Knox made considerable changes in the lay of the road, covering a distance of nearly one hundred miles, from the original Warrior's Path and from the road Boone had based on it; however, in what is now Bell County, the road followed pretty much the original route.

This late 1800s view of Cumberland Gap was taken from the south side of the mountain. *Author's collection.*

Work on the road was completed in 1796, and in 1797 new Governor James Garrard saw a need for further maintenance and continued development of the road. At his urging, the legislature appropriated £500 for improvements and erection of a tollgate along the road, funds from which would be used for future maintenance.

Colonel Crockett was once again called upon, and as special commissioner he was ordered to build a turnpike and place a tollgate at some convenient point. After investigating the road, Crockett chose to place the turnpike at Cumberland Ford, already the site of a small settlement, just a few miles from the border of Kentucky and Tennessee.

Crockett's decision to place the tollgate at the ford was probably based on several factors, chief among them the fact that there was already a settlement there and because when the river was high, travelers found it convenient to camp temporarily near the ford. Most likely they camped just a mile upstream, near the site of Dr. Walker's first camp in Kentucky. The area is now encompassed by Wasioto Winds Golf Course but for years was known to local citizens as Moss Bottoms because of the Moss family farm located there. There is also a small cemetery, now largely overgrown and untended, near Moss Bottoms that is referred to as the Early Settlers' Cemetery, giving credence to the idea that travelers camped along the road in that area.

EARLY SETTLEMENTS

The placing of the tollgate at Cumberland Ford aided in settling the areas around the ford, and eventually a good-sized village sprang up around the tollgate. This all developed several years before Bell County was dreamed of; the land it encompassed was then a part of Knox and Harlan Counties and would remain so until after the Civil War some seventy years later.

The identity of the first tollgate keeper has become a matter for discussion. According to Dr. Robert Kincaid's book *The Wilderness Road*, Robert Craig was named to the position. However, family history of the Ashers, one of the early pioneer families, states that Dillion Asher served as the first tollgate keeper.

Governor Garrard's journals reveal only that Joseph Crockett was appointed to build the turnpike and tollgate. They make no mention of the first tollgate keeper. Kincaid states that Craig was initially paid for his services from tolls collected and was given a flat salary of $200 per year in 1802. The Asher family history states that in 1797, Dillion Asher built a lean-to at the spot where the bridge crosses the Cumberland River at present-day Pine Street (Kentucky Highway 66), placing him in the area at the time the tollgate was erected.

One answer to the question could be a simple matter of appointees. Craig, hired by the legislature, could have delegated the duty to Asher. This would have made Craig the first tollgate keeper according to legislative records but would have placed Asher in the position in reality. At this late date, the matter will most likely never be resolved.

Whoever was the tollgate keeper, Dillion Asher was not in the area of the ford for very long. After clearing bottomland around the ford, he entered

into a dispute with a Mr. Hogan regarding title to the land. Having discussed the matter with his brothers from Tennessee and Kentucky, Asher elected to move from the ford and relocated to Red Bird Creek Valley, an area he had passed through in 1777 in the company of his uncle, Dillion Blevins, who was taking a party to Boone's Fort. When the young Asher passed through the Red Bird area in '77, he paused long enough to plant some peach seeds that he carried with him. Now he wished to return to the area, wondering if the peach seeds had grown. When he arrived in Red Bird, he found that an orchard had sprung from his seeds, and in 1799 he built a log home near the orchard, making him one of the earliest settlers in that area.

But some areas of what was to be known as Bell County were settled much earlier than the erecting of the tollgate in 1797. In fact, some settlements sprang up soon after the old Warrior's Path was first pressed into use.

One of the earliest settlers was Richard Davis. Hailing from Pittsylvania County, Virginia, Davis heard tales of long hunters who had been into the wilderness of Kentucky. In 1766, Davis is reported to have settled on the Kentucky side of Cumberland Mountain, beneath the pinnacle. He is also said to have settled the land around the Narrows just south of present-day Pineville in the same year. In 1792, he patented fifty acres of land in the Narrows.

Davis was not alone in the wilderness, as other families began to come into the area of plentiful game and abundant land. One of the earliest landholders in the newly opened area of Kentucky was Abraham Buford, who claimed the land around Cumberland Ford in a 1781 Virginia Treasury Warrant. Shortly after that he is said to have built a log home on the site of the old Indian Mound that was located on what is now Pine Street.

Around the time that Buford established himself at the ford, others were settling the surrounding areas. In 1782, William McBride claimed 479 acres on Straight Creek. This land was described as "lying on a big creek…about 70 poles above where the Kentucky Road" crosses the river. Also in 1782, Robert Buckner claimed 1,000 acres on Straight Creek, along the first creek running into the Cumberland River. This land was on the north side, above where the road crossed the river. From a perusal of current maps, this appears to be the land around Breastwork Hill in the Newtown section of Pineville.

One of the largest claims in the 1780s was one for twenty thousand acres along Straight Creek in 1785. Made by George James, the claim began at the mouth of the first creek above where the settlement road crossed.

Although a major community along the Wilderness Road, Cumberland Ford and its surrounding area was not the only land being settled in Kentucky in the late 1700s and early 1800s. The Yellow Creek Valley,

in which the city of Middlesborough now lies, was settled soon after the Wilderness Road opened. Early settlers in the Yellow Creek Valley area were the Marsee, Turner and Henderson families. In 1775, Bryce Martin and Richard Henderson entered a claim for five hundred acres along the first creek northward after crossing Cumberland Gap.

Sometime between 1775 and 1785, John Turner also settled in the Yellow Creek Valley. Several members of the Turner family in the area are descended from this pioneer settler. Another early claimant of land in Yellow Creek was Joseph Marsee, who arrived in the valley between 1780 and 1790.

The land along the main thoroughfare of the Wilderness Road was not the only area that attracted settlers. Other areas of the Wilderness Road were just as quick to be claimed and developed as homesites. Little Clear Creek lies on Kentucky Highway 190, south of Pineville, off the road to Frakes, Kentucky. About 1790, this area was settled by James Lake. He selected a piece of level ground covering approximately one hundred acres. John Smith was another early settler of the Clear Creek area, arriving about 1800. He settled at the foot of the Pineville side of what is now called Smith Hill.

A family by the name of Haynes also settled early—between 1780 and 1820—along Clear Creek. They erected a water mill, perhaps the first, on the creek. They also planted a large walnut orchard that bore nuts for many years, sometimes producing one hundred bushels in one season.

Farther north into the area to become Bell County—or, as the crow flies, just across the mountain—others began to settle the Greasy Creek section. One of the earliest in that area was Andrew McRobert. He settled along the Cumberland River just above the mouth of Greasy Creek between 1780 and 1790. With him came his son-in-law, Silas Woodson, who later moved to Missouri, where he became governor. The Ingram community was settled by Bill Ingram in 1800.

Across the river, another early community began around this time. John Goodin settled what came to be called Goodintown, which lies across the river from the Kentucky Utilities power plant.

This area is home to one of the most unique structures in the county—the octagon-shaped brick home of John Word. The home was originally built by W.E.N. Mark and later became the "homeplace" of the Goodins. The house—now in a state of disrepair—is a one-story structure of ten rooms. Each room has a three-foot foundation of dressed stone and walls approximately twenty inches thick. The bricks used in the building are of a much larger size than standard bricks and were made in a special kiln erected near the home. The original roof, now long destroyed by the elements, was a heavy sheet steel

roofing shipped from Ireland to North Carolina. From there it was transported to Kentucky by ox cart. This house is one of the earliest brick structures in the county.

It has been said by Joel Goodin, a descendant of Lizzie Goodin, that the original owner of the home disliked corners, hence the octagonal construction. Goodin also says that Mark had a fear of storms, resulting in the separate foundations for each room and the extra thick walls featured in the home.

While these communities were developing along the Cumberland River and Greasy Creek, other hardy pioneers were trekking into the wilderness of Straight Creek, Cubbage, Hance's Creek, Puckett's Creek and other areas. Settlements along the right fork of Straight Creek were sparse. Among the earliest settlers were Sammy Woollum at Jenson; Ben Howard and John Eperson at Stoney Fork; Elec Locke and Isaac Horn at Kettle Island; and Murphy Ward, just above the forks of the creek.

According to local lore, Kettle Island was so named because the first settlers to the area discovered a kettle that had been left on an island in the middle of the creek (possibly by Indians or earlier explorers).

Along the Cumberland River toward present-day Harlan County are many tributaries and valleys that were conducive to settlements. One of the first was at the junction of the river and Clear Creek, south of the Narrows. Wasioto became a settlement early in the county's history, and from there pioneers branched out along the river to places such as Calloway, which may have been founded by a member of one of Daniel Boone's parties into Kentucky, possibly a relative of Colonel Richard Calloway, who went on to help found Fort Boonesborough. Others settled in areas like Pittman's Creek, Sam Low Branch, Browney's Creek and Blackmont.

Stories survive detailing how Brownie's Creek (which is spelled Browneye's Creek on some old maps) and Cubbage were named. It is said that brown buffalo roamed the Browney's (original spelling) Creek area and early explorers called them "Browneys," resulting in the creek name. As for Cubbage, there are two stories as to how it was named. One source says that a cub bear was killed in the area and from that event the name Cubbage Creek developed. The other story is that a man by the name of Cubage was in an early hunting party in the area. Cubage suffered frostbite to his feet, forcing the party to camp there for several days, and after that the creek was named after him.

One of the earliest settlers in the Calloway area was Lewis Green, who served as a private in the Revolutionary War. It is said that he settled along

the Cumberland River "17 miles from Harlan Court House, before 1800." He died in 1835.

In 1799, there was an early settlement of several families in the Yellow Creek Valley. Following a government survey, it was decided that these families had homesteaded on what was Indian Territory, as outlined by the Treaty of Holstein (Holston) of 1791. This survey of 1799 determined that the divisional line between the United States and the Indians commenced at Campbell's point, which the survey perceived to be on Cumberland Mountain, placing the Indian lands in the valley where Middlesborough now sits. Based on this survey, Captain Ball, under orders from the War Department, marched his troops into the valley and destroyed the crops and cabins, routing the settlers.

In 1803, the dispossessed farmers sought damages from the federal government for the loss of their cabins and crops, and the United States hired surveyor R.J. Meigs to investigate their claims. Meigs determined that the survey of 1799 had been inaccurate and the placing of Campbell's point had been in error. His report stated, "It is my opinion that the point of Campbell's line is not on Cumberland mountain proper; but is on a part of some pile of mountains, but not on the main ridge…The mountain on which the point of Campbell's was fixed is called Double mountain."

Meigs further stated that he, with the help of disinterested parties Colonel Ballinger and Major Moore, had estimated claims that would satisfy the settlers who had been forced from their farms. His recommendations were:

William White	*3 cabbins and cleared land*	*579*
John Brown	*3 cabbins and cleared land*	*270*
William Robinson	*2 cabbins and cleared land*	*193*
Moses & John Goidon	*1 cabbin and cleared land*	*107*
Edward Giddings	*1 cabbin and cleared land*	*107*
Daniel Miller	*1 cabbin and cleared land*	*80*
Robert Belew	*1 cabbin and cleared land*	*65*
Joseph Barker	*1 cabbin and cleared land*	*60*
Samuel Moseley	*1 cabbin and cleared land*	*90*
Thompson Nichols	*1 cabbin and cleared land*	*50*
Amounting in the whole to (shillings)		*S 1601*

Of those listed in the report, only John Brown, William Robinson, Moses and John Goidon, Edward Giddings and Thompson Nichols had returned to the Yellow Creek Valley after their homes were destroyed.

Meigs's report also stated,

> *I think there ought to be a deduction from the demands of the three first named persons of at least S 150 in the whole. Some of the houses were good houses of the kind; logs hewed and well laid up.*
>
> *They had better go off and appear willing, as from the small quantity of good lands there, they can never be farmers. The principal object of many of them was to keep poor houses of entertainment, of which there is no need there, for if those on the lands all go off there will be only six miles between two good houses of entertainment.*

The congressional committee of claims ruled on Meigs's report and the settlers' claims in 1814. Its decision disallowed any compensation to the claimants. The committee was of the opinion that the settlers must prove that they were not within the boundary of the Indian lands and did not feel that Meigs's survey had sufficiently established that fact.

Meigs's statement regarding the houses of entertainment does not clarify exactly what type of "entertainment" was offered or if that had some bearing on the destruction of the settlement and the subsequent ruling of the committee of claims.

While all these settlements were coming into being over a period of some twenty to thirty years, the old Wilderness Road became a busy thoroughfare, and communities continued to thrive along its route. Business was good for those merchants who operated inns or taverns along the way. One such tavern was that operated by Alec Moore on Moore's Branch of Cannon (then Canyon's) Creek. This was about a mile north of Ferndale. Moore and his wife, Polly, operated this tavern for several years, and it was a busy resting place for travelers along the road.

But the Moores weren't the only, or the earliest, settlers in the Ferndale area. Drury Mayes, who was born in 1771 and died in 1827, is said to be the first man to settle the land around Ferndale. A patent dated 1807 shows that he took up 150 acres there on February 12 of that year.

During this same period, a vast area within the wilderness began to be settled—an area that remained pretty thoroughly isolated until well into the twentieth century.

About 1812, W.M. and I.A. Partin came into Kentucky on a hunting trip. They were taken with the abundant game and the vast amount of unclaimed land, and they returned to their homes in North Carolina only long enough to gather their families. They returned to Kentucky and settled the rugged region of Pine Mountain at the headwaters of Clear Creek, an

area eventually known as Laurel Fork but called South America by locals due to its isolation from the rest of the world and, eventually, Frakes.

The first land patent in this area was for 50 acres to John Flanagan in 1817. This was followed the same year by a patent for 150 acres to William Reynolds.

KENTUCKY BECOMES A STATE AND CUMBERLAND FORD

During the period of migration into the area, several things were taking place to aid in the eventual formation of Bell County. In 1792, Kentucky, originally a county of Virginia, was made the nation's fifteenth state. What was to eventually become Bell County, Kentucky, was composed mostly of Knox County, Kentucky, with a few settlements lying inside Harlan and Whitley Counties.

As the new state progressed into the nineteenth century, so too did the area around Cumberland Ford. The West was opening with a vengeance, and the tiny hamlet of Cumberland Ford, so vital to the crossing of the Cumberland River, met its role in this westward expansion.

The site of the actual ford became a place of taverns and inns, chief among them the Shelby House. Governor Isaac Shelby had ordered a house to be built for him at the ford, but he never lived in the home. Instead, the house was let by James Renfro and used as a tavern. He kept passing livestock in a corral he had built close by, and after Robert Craig's term expired, he operated a tollgate and ferry at the ford.

Renfro purchased the property from Governor Shelby in 1821. Renfro's sons later sold this land to J.J. Gibson. Renfro and a boy companion were killed when struck by lightning while searching for Swift's silver mine in 1835.

Renfro was no stranger to Kentucky. According to a statement preserved by later family members, he had been in the area in 1762 and was forced to conceal himself from a party of Indians. He happened to be on the mountain across the ford from where he later operated the ferry and hid in the rocks along what we now call Breastwork Hill. While hidden, he saw the Indians "on a field of battle, carrying stones to construct a mound." This mound was adjacent to the land he later lived on when he operated the tavern. If

A view of the Shelby/Renfro House at Cumberland Ford much as it would have appeared during the Civil War. *From* The Bell County Story: The Unfolding of a Century.

Renfro's statement is correct, then he witnessed what was probably the last Indian battle fought on Kentucky soil.

Although the Shelby House was located at the actual ford, the settlement of Cumberland Ford was several hundred yards upstream at the Narrows. It was here that the old tollgate was located, businesses flourished and homes were built.

THE CIVIL WAR AND THE TRAGEDY OF CUMBERLAND FORD

Kentucky remained a border state during the Civil War, yet there was much troop activity and minor skirmishes throughout the commonwealth. The area around Cumberland Ford and Cumberland Gap was no exception, especially as the formidable old gap and the old Wilderness Road remained the main entryway into the West from the southeast.

No major battles were seen on what was to become Bell County soil, yet both the Union and Confederate forces knew the value of the gap and the ford, and much "changing of hands" took place during the war years. The entire area—from the saddle of the gap through the Yellow Creek Valley into Moss Bottoms and thus to the ford—was of great importance in moving troops and supplies along the road into the rest of the state.

Early in the war, shortly after the Battle of Bull Run, the Union forces recognized the importance of the Cumberland Gap area. Samuel P. Carter and William Nelson, both lieutenants in the United States Navy, were selected for the task of recruiting these armies and putting into effect the plans to control the gap.

By the end of August 1861, over one thousand East Tennesseans, loyal to the Union, had joined the army recruited by Carter. These troops were gathered at Barbourville at Camp Andy Johnson and were formed into the First and Second Regiments of Tennessee Volunteers, U.S.A.

With no provisions, no weapons and no uniforms, Carter discussed his situation with Lieutenant Nelson, who had formed his troops at Camp Dick Robinson near Danville, Kentucky. The two decided that Carter's men should be moved to Camp Dick Robinson for training and to be equipped with arms and uniforms.

Shortly after the move, on September 9, Confederate general Zollicoffer ordered three regiments poised at the Cumberland Gap to march into Kentucky. As they made their way into the Yellow Creek Valley, they met the home guards commanded by Colonel John C. Colson. Colson was a preacher and merchant in the Yellow Creek Valley and his men were mostly pro-Union in their sympathies. They met the Confederates with squirrel rifles and shotguns but were quickly defeated, and Colson was taken into custody.

In the ensuing days, Zollicoffer moved troops to positions on each of the three Log Mountains and set up Camp Buckner at Cumberland Ford. It was probably at this time that the Confederate troops took control of the farm of Rufus Moss in Moss Bottoms near the mouth of Clear Creek. After the war, Moss related to his daughter-in-law his dissatisfaction with his treatment at the hands of the Confederates. He told her that they seized his farm, ordering him to leave, and allowed him to take only two horses and what he was able to carry in two bedsheets. Moss went to the farm of a friend in southwest Virginia and remained there until the war's end, when he returned to reclaim his farm.

General George H. Thomas was sent to Camp Dick Robinson to take command of the troops, and Lieutenant Carter was commissioned a brigadier general over the Tennessee recruits. Lieutenant Nelson, also commissioned a brigadier general, was sent to northeast Kentucky to command the troops there.

Zollicoffer spent the next few weeks more strongly fortifying Cumberland Gap.

On November 8, 1861, Union forces burned bridges between Knoxville and Chattanooga and between Knoxville and Bristol. Carter and Thomas's strategy was to march on Cumberland Gap when the bridges were destroyed, but their planned march was stopped by order of General William T. Sherman. General Don Carlos Buell later replaced Sherman, but his view of the situation was the same and he refused to allow a march on the gap. Carter and Thomas kept up a steady barrage of requests to Buell, but to no avail.

Even President Lincoln took a position, urging Congress to construct a railroad connecting the "loyal regions of East Tennessee and Western North Carolina…with Kentucky." But a doubtful Congress took no action.

Still, Carter's forces waited, doing road work to fill the chuckholes along the Wilderness Road with stones and timbers in an effort to make the road more passable.

Eventually, in April 1862, Major General George W. Morgan was sent to General Carter's brigade headquarters at Cumberland Ford as

commander of the newly formed Southern Division of the Army of Ohio. His objective? To implement the delayed and long-awaited advance toward Cumberland Gap.

Morgan was convinced that a direct assault from the north would be repelled, and he had planned a flanking attack through Roger's Gap and Big Creek Gap west of Cumberland Gap. This movement would take his troops through the dense wilderness of "South America."

At the Moss house in Moss Bottoms, just south of Cumberland Ford, Morgan stopped his troops and massed his men as if preparing for a direct assault on the gap. After night had fallen, he sent the various brigades toward Rogers and Big Creek Gaps by way of the road leading along Clear Creek at the base of Pine Mountain.

A brigade under the command of Colonel John Fitzroy de Courcy, taking the left fork at Lambdin's house in what is now Frakes, Kentucky, headed toward Rogers Gap. The first to cross over this steep mountain range, this brigade dragged the artillery (consisting of twenty Parrott guns of four tons each and a train of 120 wagons) seven miles up to the crest using a dozen mule teams to each gun, hundreds of men, ropes, chains and block and tackle.

As this brigade was completing the crossing, General Morgan received a message from General Buell for his troops to fall back to the Cumberland River and begin preparations for the advancement of Confederate general Kirby Smith's troops. De Courcy's brigade began the retreat through the gap they had just crossed, and for the next twenty-four hours the artillery, wagons, mules and men climbed back across the mountain into South America.

Just as the final units reached the northern base of Pine Mountain, de Courcy was notified by a scout that the Confederates at Cumberland Gap appeared to be preparing to evacuate. This information was relayed to General Morgan, who in the meantime had received a second message from General Buell countermanding the order to retreat and telling Morgan to use his own judgment. In view of this, Morgan stopped the retreat, and for the third time in forty-eight hours the soldiers of de Courcy's brigade began the arduous task of crossing Cumberland Mountain.

After all units reached the rendezvous point at the southern base of Roger's Gap, they began to advance east toward Cumberland Gap, which they found evacuated and the campsite in ruins. A flag was unfurled on the pinnacle and Morgan notified Washington that the gap had been taken.

Morgan, planning to move farther into east Tennessee to take possession of the railroad between Knoxville and Bristol, languished at the gap while

Generals Bragg and Smith of the Confederacy prepared to invade Kentucky. Smith's twenty-five thousand troops, using a flanking movement similar to that of the Union just a few months prior, entered Kentucky by way of Rogers and Big Creek Gaps. Troops commanded by General Stevenson faced him from the south in Powell Valley, and with Smith's men at his rear along the Wilderness Road, Morgan's ten thousand troops were completely surrounded. The Confederates took Cumberland Ford and moved on to Barbourville, where they gathered in force.

Morgan's troops remained isolated at the gap, all communication with the outside terminated when the telegraph lines were cut at Cumberland Ford. For over a month his men existed on low rations and meat carved from starved artillery mules. Finally, evacuation and retreat seemed the only logical course. Morgan's last general order issued at the gap, No. 64, ordered the evacuation to begin September 16.

The next major event at Cumberland Gap was a visit from Union general U.S. Grant in January 1864. After a night at the home of J.H.S. Morrison on the south side of the gap and a morning spent inspecting the fortifications of the gap itself, Grant led his companions underneath the pinnacle and started the descent into Kentucky. Crossing the Yellow Creek Valley, Grant and his entourage made their way to Cumberland Ford. They were disappointed in what they found along the way—a road in such disrepair that it was rutted too badly for wagons to pass. They also observed the carcasses of dead horses and mules and broken-down wagons strewn the entire distance of the fourteen miles from the gap to the ford.

Grant and his party continued on their way to Barbourville, where they spent the night at the Ben Eve Hotel before moving on into the bluegrass country. With Grant's finding of the gap and the road unusable for massive troop movements, the main events of the war came to an end in southeast Kentucky.

Although there were no major battles in the confines of what would soon become Bell County, there was still much activity during the war. Troops were garrisoned at Cumberland Ford by both armies at various times, and the old Shelby/Renfro House was used as headquarters for both forces. Breastworks were established on Breastwork Hill across the Cumberland River from the Shelby/Renfro House, and cannon were placed on the precipice of Poff Hill (the mountain on the opposite side of present U.S. 25E at Wasioto Winds Golf Course) to command a view of the Cumberland River toward Mount Pleasant (now Harlan) and of the Narrows leading to the ford, as well. Rifle pits dotted the hillside of Pine Mountain, providing coverage of the road to Clear Creek.

This photo is of one of the rough-carved sandstone grave markers in the Early Settlers'/ Poor Farm Cemetery within the boundary of Pine Mountain State Resort Park. The date on this stone appears to be 1825. This cemetery was also used during the Civil War. Author's collection.

Scott Partin of Frakes, Kentucky, recalled that his grandmother told him of troop activity during the war. She and her family were then living near the Moss house, along the Clear Creek Road, and she told Scott that the soldiers came and took part of their land for a "buryin' ground." This seems to bear out, as there is a decades-old cemetery that contains upward of 150 graves located within the boundary of Pine Mountain State Resort Park, along the road leading to the Laurel Cove Amphitheatre.

Many historians claim that there are no Civil War burials in the Bell County area, but Partin's story would seem to contradict this. It has been determined that this cemetery was used years after the war by the County Poor Farm and that at least one of the residents of the farm who was buried there was a Civil War veteran. Pleasant North, who enlisted as a Union soldier with Company F, Forty-ninth Kentucky Volunteer Infantry, on June 22, 1863, is listed by the Registration of Graves, Veterans of All Wars, as being buried in the County Poor Farm Cemetery. The exact location of his grave is unknown and there apparently is no stone to mark it. Records at Arnett & Steele Funeral Home in Pineville support this information, showing that it buried, for the county, one Pleasant North, who died June 26, 1923, at the County Poor Farm.

Other Civil War activity in the area includes what one historian has referred to as the Cumberland Ford Tragedy. Following the Confederate army's retreat after the Battle of Perryville, forces under the command of General Kirby Smith captured Captain Herbert King, a member of the Lincoln County Home Guard, and fifteen of his followers. They were sentenced to death, but in view of the hasty retreat, execution was postponed and the prisoners were forced to march along with the rear guard of "Fighting Joe" Wheeler's forces, a part of Smith's army, as they made their way toward Cumberland Gap. Eventually, on October 23, 1862, Wheeler's men halted their prisoners on the south side of the Cumberland River, just west of Cumberland Ford. A tree was selected for the gallows and King and his men were hanged, one at a time. As they were cut down from the tree, the bodies were tossed into a common grave.

On October 28, the grave and bodies were discovered by C.E. Hobbs of Crab Orchard, Kentucky, who had been searching for King and his men. He described the find in a letter to the Louisville *Daily Journal*:

> *We found a pit, removed the slight covering of dirt and there was presented the most horrible sight that ever human eyes beheld in a Christian land. Sixteen men in one pile, some of them with their hands tied behind them, some with a rope about their neck, some on their back, some on their faces, some stripped to their shirt and drawers, some with apparently their own clothing on. They were in such a state of putrefaction that they could not be recognized by their features. From the appearance of the hair and beard and all other proof Capt. King and his two sons…were in that horrible pile.*

Hobbs and his party reburied the bodies. In November, William King and a half dozen others came to Cumberland Ford to recover the bodies of his brother and nephews; the remaining thirteen bodies were left in the mass grave.

Interviews in the 1970s with Richard Davis Golden and Charlie Smith, both of Pineville, shed a little more light on this hanging. Both Golden and Smith claimed that the tree used for the hanging was in what was then the backyard of Smith's home on Valley Road; its stump was still standing at that time. They also speculated that the mass grave was located somewhere in the vicinity of Pineville Community Hospital or underneath that portion of U.S. 25E that runs in front of it.

A humorous story taken down by H.H. Fuson tells of Bill Partin, who would become a well-known Baptist minister in the county, but at the time of the Civil War he was a member of a company led by John Goodin. Goodin

was captain of a company of soldiers in the Forty-ninth Kentucky Regiment of Volunteers and was later to become one of the two "main men" who secured the formation of Bell County.

Partin decided during an inspection one day that he was going to slip through the lines and get some whiskey. He told Captain Goodin of his intention, and the captain told him that he wouldn't be able to get through the guards.

The resourceful Partin saw a group of boys rolling a barrel past the guards. For a few cents he obtained the use of the barrel. He got into the vessel and let it roll through the lines. After the guards had passed, he clambered out of the barrel and was on his way for the whiskey. He got the liquor, but as he was returning a guard spotted him and captured him. He was ordered to the guardhouse, where the officers found him guilty and ordered him to carry a large pole across his shoulders as his punishment instead of being imprisoned. He complained to the colonel that he was too small a man for such a large pole and the colonel agreed, returning him to the guardhouse, which he proceeded to set on fire. As there was no longer any guardhouse to hold him, Bill had to be released!

JOSH BELL COUNTY FORMED

A grandson of Thomas Walker began efforts in the Commonwealth of Kentucky legislature to establish a new county. Serving in the legislature from 1864 to 1867, Joshua Fry Bell suggested that Harlan and Knox Counties were too large and fought to have them divided into three counties.

Bell, born in Danville, Kentucky, November 26, 1811, a little over a half century after his ancestor had first stepped on Kentucky soil, had spent most of his life in public service. He served a term in Congress and then became secretary of state. Due to his logic and eloquence, he was often referred to as "Bell of the silver tongue." His eloquence was put to the test in the legislature, and eventually the formation of Kentucky's 112th county was agreed to. It was to be named Josh Bell County, in his honor.

On September 9, 1867, the newly formed Josh Bell County Fiscal Court met at the home of C.B. Brittain, near Wasioto. Lewis F. Payne had been selected to serve as first county judge, with James H. Lee as county clerk and C.B. Brittain as deputy clerk. Magistrates, or squires, were William H. Baughman, Joshua B. Cox, William M. Bingham, Herod Hendrickson, Stephen Rice, Sampson Miracle, James R. Fuson, William L. Evans and John Burns.

The new court of Josh Bell quickly began the task of organizing the government, with one of the first pieces of business being the selection of a town site. There was already a community at the bottomland near the ford, but the court opted to have the town site of Cumberland Ford, which was to be the county seat, laid out along the Narrows of the Cumberland River, upstream from the existing settlement. This location was chosen on October 15, and M.G. Jones was employed to lay out the town site, providing for the various streets and roads and sites for public buildings. His fee for this service was ten dollars.

Map of Josh Bell County, formed in 1867 from portions of Harlan, Knox and Whitley Counties. *Author's collection.*

In early 1868, the court passed a property tax of ten cents per $100 to help in erecting the necessary public buildings. By 1871, contracts had been let to construct the first jail and courthouse, both situated in the Narrows along the right side of the road traveling south. When the jail was completed in 1873, Joseph Shell became the first jailer.

The name of the county remained Josh Bell until 1873, when the Josh was simply dropped from the name by the local court. Later action was taken by the state legislature to make the official name Bell County.

Amidst the flurry of activity in the new county seat, other businesses besides government were flourishing. As William Bingham was returning from a session of the court one day in 1868, he stopped in at a small store in Cumberland Ford operated by John Brogan of Barbourville. Bingham began a conversation with Brogan, telling him that he was tired of farming

Sarah Bingham Moss, daughter of Captain William Bingham, became the first permanent female resident of Cumberland Ford. She settled there with her father to help him in his general store. *From* The Bell County Story: The Unfolding of a Century.

his plot of land six miles up Straight Creek. It seemed that Brogan was tired of his vocation of store owner as well, so the two struck a bargain and Bingham left Cumberland Ford as owner of a general store. When he arrived at his Straight Creek farm, he informed his wife that he had bought the store. She told him that he knew nothing of running a store and that she would not move to Cumberland Ford. Both being of stubborn pioneer stock, neither would give on the issues of the store and living in Cumberland Ford. Bingham settled the matter by moving to the store and taking his eleven-year-old daughter along to help him. Mrs. Bingham, true to her word, remained on the farm and never moved to the county seat.

Although he was not aware of it at the time, Bingham was making history; by bringing his daughter, Sarah, with him he was also bringing the first permanent female resident of the town.

Bingham and Sarah settled into the business of being store keepers in a building situated along old Cumberland Avenue on the riverbank almost directly behind the present-day Off-Track Betting Facility.

Seventy-three years later, at the age of eighty-three, Sarah recalled her first trip to the town. She remembered seeing the breastworks built by the Civil War soldiers on Breastwork Hill. She recalled the rapid growth of the new town and that her father very soon had competition across the street from his store from a general store opened by Peter Hinkle.

CUMBERLAND FORD THRIVES AND MIDDLESBOROUGH BEGINS

Cumberland Ford continued to thrive throughout the 1870s and 1880s. Here and there new businesses and residences sprang up; a newspaper—the *Messenger*—came to town. All the accoutrements of a county seat were in evidence.

It was during the 1870s that T.J. Asher, grandson of early settler Dillion Asher, began his rise to eminence. T.J. married Varilla Howard May 3, 1870, and moved with his bride to Calloway, Kentucky, where Puckett's Creek joins the Cumberland River. Living in a log home, they farmed their parcel of land along Puckett's Creek. Robert Howard, Varilla's father, introduced his son-in-law to a buyer with the Southern Pump Company, and Asher soon negotiated a contract to cut and snake walnut logs to a high-water mark in the river. T.J. eventually parlayed this logging operation into a logging and lumber business that, by the end of the next decade, would form the basis of what was to become one of Bell County's best-known empires.

The little county seat of Cumberland Ford continued to grow, but not overly so, due to the physical limitations of the Narrows in which it lay.

It was during the 1870s that Bell County began to garner some notoriety of a national scope. In that year, artist Harry Penn and writer Felix Gregory de Fontaine ventured into the area. Their work would be included in William Cullen Bryant's *Picturesque America*.

De Fontaine and Penn were not the only noted visitors to Bell County in the 1870s. In 1875, notorious Missouri outlaw Frank James paid a visit to the Henderson clan in South America, having apparently made the acquaintance of some of the Henderson men during the Civil War. As James and a companion bid farewell to the Hendersons. they rode out of South America by way of Clear Creek. Arriving at the Wilderness Road south of

Cumberland Ford, they fell in with other riders on their way to Tazewell. James was en route to Tennessee to visit another old army acquaintance, Ben Shults. The riders were going to Tazewell to witness the execution of Annanias Honeycutt for the murder of Thomas Ausmus, a prominent farmer in Powell Valley. Arriving at the execution site, James gave a local resident five dollars in gold for his place in the schoolhouse window in order to have a better view of the hanging.

At least twice during the 1870s, there were attempts to charter Cumberland Ford as the city of Pineville, but both times the incorporation failed and the county seat remained the Narrows village it had started as in 1867. However, these incorporation attempts did cause the name Pineville to be used occasionally instead of Cumberland Ford. There had been some talk of the railroad extending its lines into the area, but the steel rails were still some ten years from making Bell County more accessible.

The late 1870s and much of the 1880s saw a little more expansion and development of the area. Some far-sighted persons had begun to explore the mineral deposits in the region, and coal was being mined in some parts of the county, although mostly for personal use in heating and cook stoves and usually as a family venture on an "as-needed" basis.

It was also in the 1880s that another writer of national prominence presented his views of Bell County. In 1885, James Lane Allen toured the area along the old Wilderness Road on horseback. Writing later in *Harper's New Monthly Magazine*, he recalled visiting with an eighty-year-old woman and crossing the Cumberland Ford, which was two to three feet deep and "clear and placid." The county seat—which he referred to as Pineville—was the scene of some trepidation for him when he stopped for a meal. While dining, he learned that a shooting affray a few days earlier had resulted in a line being drawn through the town, with those living on one side or the other crossing the line at some risk to their lives. Allen hurried his meal and quickly departed, journeying southward through the Yellow Creek Valley toward the Cumberland Gap.

The growth pangs of the 1880s finally pushed the little town of Cumberland Ford to its limits, causing it to evolve into the city of Pineville. The little village of the Narrows was trying its best to become a little city, especially as the railroad made its way south. By 1886, the Louisville and Nashville Railroad (L&N) began to extend its line southward from Corbin to Pineville, which, although four years from its final incorporation, was beginning to develop as a planned town site in the bottomland around the Shelby/Renfro House acquired from J.J. Gibson.

This section of an 1888 map shows the location of some of the early businesses in the city of Pineville. Most of the business district at that time was situated in the Narrows. *Author's collection.*

Cumberland Ford was not alone in its growth into a city. In nearby Yellow Creek Valley, in the "bowl" at the base of Cumberland Mountain on the northern side of the pinnacle, a young Canadian of Scottish descent began planning a city of his own. Alexander Alan Arthur first came into the Yellow Creek Valley in 1886. So impressed was he by the natural beauty of the area,

with its natural propensity for a town site, and not least of all with the iron ore samples he had picked up, that he rushed back to Newport, Tennessee, to gather support for his plans for a dream city.

Arthur had originally been sent to Bell County by the Richmond and Danville Railroad (R&D) to explore the possibility of a line from Morristown, Tennessee, to open the coal fields of eastern Kentucky. On his return to Newport, Arthur found that the R&D had merged with the East Tennessee, Virginia and Georgia and that plans for a Kentucky line had been halted. Undaunted, Arthur went to Asheville, North Carolina, to seek out supporters for his city. There he found several members of wealthy eastern families willing to take on an adventure. Among them were F. Randolph Curtis, James S. Churchill, J.H. Martin, John Barnard and Edward Herrick. This group of the "idle rich" returned with Arthur to Bell County to explore his dream of a city.

Greatly impressed with the mountainous region, they returned to Asheville and looked for ways to raise the capital to build the city. It was finally decided that Arthur should go to England in search of funding for the hastily formed "Gap Associates."

He returned to the States in 1887 with engineer Sir Jacob Higson and others. Following a tour from the gap to Woodbine in Knox County, the southern terminus of the L&N at that time, Higson cabled London with a recommendation that the backers purchase the Gap Associates' options. The American Association, Ltd., was formed, with Arthur as general manager and chief American representative. Soon the association owned or had optioned more than eighty thousand acres in the tri-state area.

Arthur's next step was to build a railroad into the area. The hardy Scot quickly began a company to garner support for a rail line from Knoxville, Tennessee, to the Kentucky coal fields. Money flowed in and the Knoxville, Cumberland Gap and Louisville Railway Company was formed. August 1, 1899, was set as the line's completion date.

The years 1887 and 1888 were busy ones for Arthur and the American Association. Following an announcement that the Watts Steel Company of England had committed to build two blast furnaces in the area, Arthur's attention turned to the actual construction of "his city."

The obvious and optimal location was the giant bowl of the Yellow Creek Valley. This bowl, stretching northward from the base of Cumberland Mountain—in the days of Daniel Boone mostly marshes and canebrakes but now transformed into farmland and homesteads—was ideally situated as a hub for all the outlying mining operations that were expected to begin.

Arthur and his companions had searched for a name for the new town, and someone in the group mentioned Middlesbrough, England, which had

just a few years before risen to commercial prominence. The new town in the making was named Middlesborough—an extra "o" was later added between the "b" and the "r"—which was soon shortened to Middlesboro, except for official documents and names. The Kentucky city is pronounced "Middles-burr-o," with a long "o," while its namesake is pronounced, in the British fashion, "Middles-bruh," with a short terminal sound.

As a subsidiary to the American Association, Arthur formed the Middlesborough Town and Land Company to buy and sell acreage in the new city. A total of 5,500 acres had been purchased for the town site, with the actual mapping of the town done by Colonel George E. Waring Jr. On July 16, 1888, the first stake was driven to begin the town survey. Cumberland Avenue, one hundred feet wide and four miles long, was the main thoroughfare for the city. The old Wilderness Road, well worn by untold thousands of pioneer feet, branched off the new avenue toward the county seat. It was renamed Fitzpatrick Avenue. Streets parallel to Cumberland Avenue were given English names: Chester, Ilchester, Dorchester, Manchester, etc., and the cross streets were numbered. Three hills in the town were prepared for building and named Arthur Heights, Queensbury Heights and Maxwellton Braes.

With an eye to the periodic flooding that had plagued the valley, Waring planned a canal to divert Yellow Creek, which crossed Cumberland Avenue

Laborers at work on the canal in Middlesborough. The canal was constructed to divert Yellow Creek, which crossed Cumberland Avenue thirteen times, around the city. *From* Pictorial History of Middlesboro and the American Association Land Companies in Mingo Hollow.

no fewer than thirteen times, from the center of town. This canal, dug by hundreds of Italian laborers imported specifically for that job, was one hundred feet wide.

Englishmen, Italians, Hungarians and other Europeans mingled with the laconic native Kentuckians in the hastily erected tent city as workmen rushed to build a city and speculators rushed to build businesses.

MINING AND RAILROADS COME TO THE COUNTY

A flurry of building and business activity was very much in evidence in the northern end of the county in the 1880s. Coal mine operations were beginning at Wallsend and at Straight Creek in response to the advancement of the L&N line as far south as Pineville, en route to Norton, Virginia. The railroad provided a practical means for moving coal to the northern industrial markets, making the eastern Kentucky coal fields a very advantageous place to begin a business.

This increased activity contributed to the move of many businesses from Cumberland Ford, the town, to Cumberland Ford, the river ford. By decade's end, Cumberland Ford the town would be no more; it would effectively become a part of the new city of Pineville.

The little county seat in the Narrows had not grown very much since the formation of the county. It had remained a scattering of government buildings, a couple of hotels, a blacksmith shop, a couple of general stores and various homesites. However, as the railroad approached and the mining industry began to take shape, Cumberland Ford felt the need for expansion.

A view of Cumberland Ford and its thriving status as a bustling county seat was preserved in Earl Morgan's memoirs, published in the 1980s. Morgan related memories that his father, J.P. Morgan, had of the town he first viewed almost one hundred years earlier.

J.P. Morgan had come from central Kentucky with an eye toward making his fame and fortune in "the Big Mountains." Reaching the little town on a summer day in 1885, Morgan found it crammed into the Narrows, with the log courthouse and jail on the right side of the road as he entered the valley from the north. Along this same side of the road were other

businesses—saloons and a general store (most likely that of Peter Hinkle). He noted that most of the businesses and homes were on the hillside above the road, as the river was so close to the road itself that there was little room for building on the left.

Exploring the town, he found one business in particular that caught his eye. Its sign read, simply, "Cook House." It was there that he had his first meal at Cumberland Ford: steak, potatoes, beans, cornbread and apple cobbler, all for twenty-five cents.

Morgan was not destined to remain at Cumberland Ford. After his meal he met an old, Native American herbal doctor named Max. They struck a fast friendship, and Morgan began practicing medicine with Max, a practice that would cover most of the Laurel Fork and Clear Fork areas of Clear Creek for twenty years. Morgan eventually married and settled in Morgan Hollow, a small hollow just inside the Kentucky border, near Pruden, Tennessee.

J.P. Morgan also recalled the Great Flood of 1886. The Cumberland River Valley had been—and still is—plagued by periodic flooding, and his mention of the 1886 "tide," as floods were called locally, is one of the earliest recollections of flood damage done to the town. He recalled that this flood had caused such widespread damage that, in its aftermath, some stores and homes were relocated on higher ground. Some were never rebuilt. Logs and debris of all sorts were strewn throughout the town.

Another incident recalled by "young doc," as J.P. was called to distinguish him from Max, or "old doc," was the shooting affray written about by James Lane Allen. It had taken place shortly before J.P. came to Cumberland Ford, but he learned all about it from local residents. There had been an ongoing feud among members of the Turner family and the latest scrape had left six dead from gunshot wounds. Those responsible were being tried at the courthouse when the feud erupted anew and guns once more were blazing. The opposing attorneys, Gil Colson and W.G. Anderson, fled the courtroom by different windows. If fleetness of foot had counted for proficiency in the law, then Anderson would have been the clear winner that day; by the time Colson had defenestrated himself and run to the nearby hotel, his adversary at the bar was already there, relaxing in a rocking chair on the hotel porch!

The east Kentucky coal field came into its own during the 1880s, especially with the extension of the L&N line into Bell County, which provided means of transporting the mined product to the northern industrial centers. Several mining companies began to form, and the natives—who had been farmers for the last few generations—now began to take employment as miners.

The first mine to begin producing coal in Bell County was the Wallsend Coal and Coke Company. Located on the mountain across the river from

One of the earliest coal mines in operation in Bell County was the Wallsend Coal and Coke Company just north of Pineville. Above is the commissary and offices of the company. *Author's collection.*

the bottomland that was being laid for the city of Pineville, Wallsend Coal and Coke began producing coal in 1889. Wallsend is named for Wallsend, England, and not, as many younger residents think, because the Pineville floodwall ended across the river from the community.

Paralleling the development of Wallsend was the founding of Straight Creek, both the community and the mine. Pine Mountain Iron and Coal Company owned several hundred acres along the Straight Creek and leased much of it to Cumberland Valley Colliery, which began the mine there under the supervision of Colonel J.H. Allen. The community of Straight Creek, located a short ways upstream from the forks of the creek, grew up around the mine.

Pine Mountain Iron and Coal, with its leased mining venture on Straight Creek and its landholdings in the bottomland around the river ford, became a mover and shaker. It was the impetus behind the final design and incorporation of the city of Pineville, and through its promotional efforts Pineville was to become a name familiar to businessmen up and down the eastern seaboard.

Many of the lots in the Pine Mountain Iron and Coal Company's holdings were sold during the company's initial push of the area in 1888. Plans had been drawn for a new courthouse, to be located on a central "town square," bordered by Pine and Walnut Streets and Virginia and Kentucky Avenues. Access to the new mining company and community of Straight Creek was made easier by the construction of a steel bridge spanning the Cumberland River just a few hundred feet upstream from the old river ford. A similar bridge linked Wallsend and Pineville in 1889.

Not yet incorporated, Pineville nevertheless saw the coming of various businesses in 1888 and 1889. On Pine Street, opposite the courthouse, Dr. D.C. Burchfield built a frame building to house his hardware and mercantile business. A few lots down the street (toward the corner of Pine and Kentucky), Jeff Hoskins erected a similar store. Soon to follow were the Bingham Building and a handful of smaller buildings around the square. Along Park Avenue, the homes of Judge Moss, the Ramseys and the Shaffers appeared.

One of the more impressive structures in the new town was the Pineville Hotel, a rambling wooden structure on the lots on Kentucky Avenue between

Pineville Hotel. This imposing frame structure covered most of the block at the corner of Laurel Street and Kentucky Avenue in Pineville. It was reduced to ashes by fire in 1890. *From* Pineville, Kentucky, *promotional booklet by Pine Mountain Iron and Coal Company, 1888.*

Laurel Street and Catalpa Street. Built at a cost of $25,000, this expansive building featured towers at either end of the front of the structure, awnings on some windows to block the early morning sun and a network of fireplaces and chimneys to heat the rooms. At the time, it was the most impressive hotel in the area.

L&N had not yet completed its line to Pineville in 1888, yet it did manage to run a few cars from Fourmile to accommodate the throng of people pouring into the area to buy lots in the valley as the city of Pineville became a reality.

PINEVILLE INCORPORATED

The closing months of 1889 saw the addition of the Hull and Barclay sections of Pineville to the holdings already maintained by Pine Mountain Iron and Coal Company. The Hull and Barclay addition encompasses a vast portion of the downstream area of town, in the bend of the river as it approaches Wallsend. With all the lots of Pineville now available for building, the city was officially incorporated in 1889. A city council composed of T.J. Hoskins, J.B. Bowman, J.W. Johnson, M.J. Moss and Baxter Beatty was named late in 1889, and in early 1890 this body chose T.J. Hoskins to serve as mayor.

The original incorporated lands of Pineville encompassed a larger area than the city limit of today. As first mapped and plotted, the city limit was to extend two miles from the central court square in an octagonal design that would have taken in Wasioto, Log Mountain, the forks of Straight Creek and a large portion of land on both sides of the river northward toward Turkey Creek and Fourmile.

With incorporation a reality, Pine Mountain Iron and Coal Company stepped up its promotion of the city. It began to distribute booklets touting Pineville and Bell County as *the* place to live and work. The 1889 booklet makes it clear that Cumberland Ford, the town, is no longer in existence.

With all of this development the banking industry was a must, for what growth could the new town and industries expect without banks to support them? Until 1887, the closest bank to the area was in Stanford, Kentucky, much too far away from the rapid growth taking place. In that year, the Pineville Banking Company began operations. Money was pouring into the little town as the rush was on to get in on the ground floor of the coming boom years, and in its first year the Pineville Banking Company reported

deposits averaging $50,000 per week. Still more capital was needed, and the People's Bank opened its doors in late 1887 or early 1888.

Other professions entered the area around this time. As early as 1884, the first physician who was a graduate of an accredited medical school arrived in Bell County. Dr. Thomas S. Foley, a native of Whitley County, Kentucky, began to practice at Straight Creek with Dr. J.S. Ward. Foley was fully accredited by the Hospital College of Medicine in Louisville, Kentucky. After practicing with Dr. Ward for two years, Foley moved his office to Pineville, along the old river road (by then called Cumberland Avenue). The office was in his home and sat about a block toward the river from the intersection of Virginia Avenue and Cherry Street, an area now covered by U.S. 25E.

The second member of the medical profession to join Foley in Pineville was Dr. D.C. Burchfield, who hailed from Tennessee. Dr. Burchfield built a fine brick house on Park Avenue (on the hillside next to the old Health Department and now owned by Ron Presnell). He also entered into the business world of Pineville, operating a mercantile store on Pine Street opposite the courthouse.

By 1890, the need for another physician in the town was evident. Dr. John Foley joined his brother Thomas in his practice. John Foley served a dual practice; he was both a physician and a dentist, having taken both courses at the Hospital College of Medicine in Louisville.

Rounding out the quartet of Pineville's first physicians was Dr. Sam Blair, who arrived from Letcher County, Kentucky, in 1891.

Being a county seat, Pineville had its fair share of attorneys. In addition to the aforementioned Gil Colson and W.G. Anderson, those numbered among early attorneys were Judge Milton Unthank, William Low, William Ayers, H. Clay Rice, D.B. Logan and Napoleon Bonaparte Hayes. Each of these men contributed to the growth and well-being of the new town.

Some of these legal eagles were characters in their own right. First and foremost among them was Milt Unthank. He carried a large black umbrella on which were painted the words, "I stole this umbrella from Milt Unthank!" Needless to say, it was never stolen. Unthank also represented the interests that owned Rocky Face, the range of rocky mountain at Ferndale. When the American Association was negotiating the purchase of this land, Alexander Arthur asked Unthank what it was worth. Unthank said the only thing he knew it was good for was that when Gabriel blew his trumpet and the sea gave up its dead, it would be a good place to hang them up to dry.

Of course a new town needed a new school. The first school in Cumberland Ford was started in 1871 by J.G. Reynolds. An ungraded school serving fifteen to twenty students, this facility grew along with the

little town and was eventually moved farther downstream to the Y where Park and Cumberland Avenues were to meet, and an additional teacher was hired. Eventually, this school came under the tutelage of Napoleon Bonaparte Hayes. This was the school in operation when Pineville was planned, and the need for a newer, graded school was seen.

On June 7, 1890, the first meeting of the Pineville Public Graded School was attended by T.J. Hoskins, M.J. Moss, J.Q. Pearce, William Low and Frank Mariman. By September 1890, the board of trustees had rented space in Old Town, West Pineville (Wallsend) and in the court square area to begin the fall classes. In October 1890, land along Tennessee Avenue between Sycamore and Cedar Streets was donated to the school by Hull and Barclay and Pine Mountain Iron and Coal Company, and a contract for a $12,500 eight-room school building was let.

Schools had been established in the smaller settlements of the county as early as 1867. Not much is known of the earliest schools in the Bell County System; however, a teacher in that system recalled the years around 1890 in an essay published in 1967. Writing at the age of eighty-one, Dora Ingram Barlow recalled the Centennial Schoolhouse on Greasy Creek. "It was a large room (or so it seemed to me) built of logs," she wrote. "The cracks were daubed with clay to keep out the snow and rain. In one end was a huge open fireplace. The building was used not only as a schoolhouse, but as a meetinghouse for the Centennial Baptist Church. The benches were homemade."

Barlow wrote that not long after she started school at Centennial in 1890 her mother died, and she moved with her father to his parents' home at Ingram and transferred to a school in the Buckeye district. She remembered it as a

> *plank schoolhouse instead of a log building. It also boasted a pot-bellied wood-burning stove... The benches were homemade but in the course of a few years they were replaced with "bought seats" that had "desks" [sic]... There was no such thing as grading pupils in those days, but one's progress in reading determined to a large degree the other subjects he could take. For example, when we advanced to the Third Reader we could have a "sure enough" spelling book and a primary arithmetic... We had no paper on which to write, so we had to use slates. We had a blackboard, but chalk was only for the teacher's use. It had to be paid for by the teacher and carried on horseback from Pineville. Two or three boxes were made to last for an entire school term.*

With public buildings, businesses, homes, physicians, attorneys and schools in place, the stage was set for Pineville to enter the boom years of the 1890s.

MIDDLESBOROUGH: TENT CITY TO MAGIC CITY

Twelve miles south of the hustle and bustle of the activity around the Cumberland River Ford, Alexander Arthur was still pushing his dream city—the Magic City—forward. Still a tent city in 1888, Middlesborough was now beginning to take form. By the next year, tents had given way to frame buildings and everywhere could be heard the rasp of saws and the staccato beat of hammers as laborers filled the mapped lots with business structures. Throughout the summer of 1889, hundreds of investors, land speculators and professional men thronged the wide thoroughfares, not yet paved and—for much of the summer—pits of mud caused by the construction. By summer's end, the tunnel through Cumberland Mountain was completed, providing a rail outlet to the south. L&N completed its line to Middlesborough from the north less than a month later on September 1.

The first large-scale public sale of lots was on October 14, and over $100,000 changed hands on that day as speculators from all along the eastern seaboard, responding to Arthur's promotion of the sale, were present to make as many deals as possible. By year's end, more than 5,000 people filled the mud streets and plank walks of Arthur's dream city, and over $10 million had been spent in bringing the valley from a rural, sparsely populated area to a city with aspirations of a 200,000-plus population.

In 1890, the town was officially incorporated as Middlesborough and John H. Brooks was named as the first mayor. Although now technically in the hands of a city government, Middlesborough remained Arthur's, as evidenced by his involvement in everything from public relations to mediator to firefighter. When incorporated, Middlesborough already featured two blast furnaces at the Watts Steel Company, the tannery of Hall and Vaughn, an electric power plant to feed the streetlights and the 150-room

Middlesborough was begun as a dream and a city of tents. Here the tents of workmen and residents can be seen in the background as Cumberland Avenue begins to take shape. *Author's collection.*

Sketch of Middlesborough's Cumberland Avenue under construction in 1890. By this time, Middlesborough featured two blast furnaces at the Watts Steel Company, the tannery of Hall and Vaughn, an electric power plant to feed the streetlights and the 150-room Middlesborough Hotel. All this was in addition to banks, merchants, saloons, liveries and legal and medical practices. *From* The Bell County Story: The Unfolding of a Century.

Middlesborough Hotel—all this in addition to banks, merchants, saloons, liveries and legal and medical practices, for Arthur had foreseen every need and had imported doctors, lawyers, dentists and other needed professionals from far and wide to serve the city.

Just as the Magic City was flexing its muscles, a major setback occurred. Six businesses were razed by fire on April 20, 1890, and one hundred people were left homeless by the blaze. The last traces of this fire could still be seen along the main avenue when disaster struck again: a May 8 fire destroyed a livery stable and twenty mules and horses. Less than a month later, fire struck for the third time, with tremendous loss to the business district.

About 10:00 a.m. on the morning of June 4, 1890, an alarm was raised when fire broke out in a grocery store on Cumberland Avenue. As most of the town, right down to the sidewalks, was constructed of wood, this fire began to spread rapidly. In his office when the alarm sounded, Alexander Arthur rushed into the street to join the volunteer firefighters and merchants as they tried to control the blaze. Strong winds drove the blaze across the broad street and carried hot embers far from the main business district, igniting buildings in their path. The bucket-brigade firefighters had no hope of controlling the inferno.

Middlesborough was destroyed by fire practically before it was begun. Fire swept through the city June 4, 1890, consuming the business district in a scant two hours. The townspeople were undaunted and began to rebuild before the ashes were completely cold. *Author's collection.*

In a scant two hours, Cumberland Avenue was in flames along its length through the business district, and by midnight the larger portion of the town was in ashes. Surveying his ruined dream, Arthur cabled London for aid and was authorized to supply loans to rebuild the stores and homes destroyed by the fire. With a phoenix-like spirit, the town was rebuilt within a year, but from more fireproof materials—rock, brick, stone and concrete.

As with neighboring Pineville, Middlesborough early on realized a need for proper schools. The Middlesborough Academy is the first school of record. A private school on east Cumberland Avenue, it opened December 9, 1889, and was taught by Professor Ezra L. Grubbs.

The first public school began in the spring of 1890 in two rooms in city hall. The faculty of Professor Grubbs, Maggie Chumley and Cora Martin offered classes in English, civil law, Greek, Latin, German, bookkeeping, music and painting. By October 1890, a small frame building for the school was provided by the town council, and Professor Grubbs was named first principal. Within a year, the town council recommended that a school board be appointed. Consisting of six members and a treasurer, this board was not to run the school; instead, it was to serve in an advisory capacity to the council. Finally, in December 1891, a full-fledged school board came into being at the urging of local citizens. This board, consisting of W.H. Rhorer, F.D. Hart, W.A. Cuff, Mr. Park, Mr. Price and E.H. Pattie, had full control of the school with no influence from city government.

The year 1891 also saw the start of the first African American school in Middlesboro. Known at first as Middlesborough Colored School, it was later renamed Lincoln School. It was under the leadership of Professor George C. Bell, who had been born a slave in Marion County, Kentucky, and his wife, Elgetha Brand Bell.

With his city incorporated, businesses committed to the venture and having weathered the trial by fire, Arthur looked ahead to the decade of the '90s with great plans for the industrial center he envisioned. However, fate would take an unexpected turn…

BOOM AND THEN BUST

The boom decade of the 1890s was coming to fruition early in Bell County. Already, two prominent cities were in the offing, and a multitude of smaller communities was soon to dot the map as mining camps began to spring up throughout the county.

In Pineville, disaster of a smaller scale than in Middlesborough had struck, also in 1890. A "cyclone" swept along Pine Street, leveling the newly built stores of Dr. Burchfield and Jeff Hoskins. The buildings' collapse left Burchfield unconscious but uninjured. Those in Hoskins's store, however, were left with so much plaster dust in their eyes that they were unable to see clearly for a week.

Pineville did not escape fire, either. The large wooden Pineville Hotel was completely destroyed by a blaze, most likely in late 1890. Its backers, Pine Mountain Iron and Coal Company, rose to the occasion and renovated its office building at the corner of Kentucky Avenue and Oak Street, creating the new Pineville Hotel.

Financial disaster was looming on the horizon, even as new business began to prosper. In 1890, the Baring Brothers Bank of England, which was the principal backer of the American Association, Ltd., was forced into bankruptcy. Baring Brothers had overextended, offering too much credit to investors both in England and in America. When the bank failed, it also caused a number of private backers of Middlesborough to go bankrupt.

Arthur sailed for London in an attempt to secure more funds for the various projects already underway in Middlesborough. Millions more dollars were needed before the iron and coal company could show a profit; cash was needed on a daily basis to keep the mining and timber operations in the black; more work—costly work—was needed on the railroad. Arthur's

Alexander A. Arthur, a Canadian of Scottish descent, first came to Bell County in 1886. He was impressed with iron and coal deposits he saw and returned in 1888 to begin building his "dream city"—Middlesborough. *Author's collection.*

board of directors agreed that all the investments were sound; the money just wasn't there to continue. The Baring Brothers had felt the brunt of this revelation when monies that were due the English investors as interest on their investments in the corporation were used for construction in Middlesborough instead. Although the board did not fault Arthur, whose accounting of every penny was impeccable, it did opt to replace him. E.F. Powers was named as new general manager.

Arthur returned to Middlesborough, and the hopes of its citizens still lay with him. They had looked to his leadership since before there was a Middlesborough and couldn't fathom the halt of the boom he had started. Local investors remained optimistic. They viewed the loss of funds from England as a temporary setback and told any who would listen that the boom days would return. To prove their faith, they reinvested their own monies in Middlesborough.

Then came the news from the iron ore mine. The ore, so highly rated, proved to be of a very small quantity. Work ceased.

The domino effect was set in motion. The failure to mine high-grade ore—the basis for the city since its inception—trickled down to other businesses. The steel mill no longer had the promise of ore for its furnaces. Without the steel mill, there would be no workers or workers in related industries. With no workers, who would support the shops: the clothiers,

the hatters, the dry goods, the restaurants? Many of these businesses closed as their owners sought their fortunes elsewhere.

Things could not look bleaker. Or could they?

Early in 1893, the Philadelphia and Reading Railroad filed bankruptcy, a harbinger of worse times to come throughout the nation. Soon, prices of grain, cotton, steel and lumber began to fall and the stock market showed great instability.

By May, a panic began. More railroads failed; foreign banks sold their American stocks and bonds; there was a huge run on American banks, with over five hundred of them failing. Although the Silver Act was repealed in October, depression had set in.

And the depression was felt in Bell County—especially in already financially troubled Middlesborough. Investors, either ruined by bank failure or fearful of losing all in days to come, withdrew their backing from the Magic City's projects.

All four banks in Middlesborough failed, with depositors and shareholders receiving nothing. The belt-line railroad, built at a cost of $1 million, was sold to L&N for $30,000. The vast holdings of the American Association were sold at public auction by the sheriff.

Middlesborough hung tenaciously on, though on a less grandiose scale than originally planned, and surviving the panic and the ensuing depression it rose once again—this time from figurative ashes—as King Coal moved into the arena of the national markets.

SURVIVING THE BUST AND THE FIRST LEGAL HANGING

Though the iron industry was gone from Middlesborough, the city stayed a viable mountain town, kept solvent by the coal pouring from the nearby mines. Throughout the panic and depression of the 1890s, the mines had continued to operate. Also, the American Association, Ltd., though forced into receivership by the depression, had reorganized under the same name and managed to purchase most of its original holdings, so it remained a vital part of the area. As coal came into its own, the American Association was there with its leases to much of the coal land in the Middlesborough area—land it leased to other companies. Shortly after the turn of the new century, the association had eleven mines operating on its properties. As the depression marched on, mining stepped forward. The iron industry may have been gone from the valley, but King Coal had come to stay.

Pineville, not dependent on iron ore and large-scale mining operations, had weathered the depression years a little better than Middlesborough. It had faced a few setbacks, but as it had not felt the tremendous need for fast growth that pushed the Magic City, it had remained much as it was before the Panic of 1893. Coal was to be the saving grace of both cities.

The mines continued to open in surrounding areas, and with the mines came miners and their families and paydays that could be spent on Friday and Saturday nights at the local saloons by the men and in the stores on Saturdays by the women. For the most part, these miners were a peaceful lot. To be sure, there was the usual Saturday nightlife, sometimes resulting in a night in jail while the imbiber "slept it off," but for the most part the area remained sedate.

One noted purveyor of the Middlesborough nightlife was young Benjamin Robertson Harney. Arriving in the boomtown about 1890,

Although severely damaged, this photo shows a group of Bell County miners, circa 1920s. The location of the mine is unknown. *Author's collection.*

Harney first worked as a news reporter, then as a postal clerk and later as assistant postmaster, but his true love was music. Harney was a piano player, and he spent his spare hours playing in the saloons and honkytonks along Cumberland Avenue. There he was introduced to a variety of musical styles. Many of these early establishments were integrated, so the young Louisvillian was able to hear much African American music, mixed with European gypsy strains, Latin beats and a smattering of good old mountain music thrown in for good measure. He began to intermingle these styles and was a popular artist in the many joints along the avenue. By the time Harney returned to Louisville, he had adapted much of what he had heard in Middlesborough into his playing style and performed it on stage. It was a different sound, but one that the country was soon to know as ragtime. Harney published his first rag, "You've Been a Good Old Wagon, But You've Done Broke Down," in 1895, some four years before Scot Joplin published his first ragtime piece.

However, the year 1893 did bring a tragedy to the area: the death of one miner from Bennett's Fork as the first person to be legally hanged in Bell County. The tragedy was the accidental shooting of a young mother, a death brought about by a debt of nine dollars and a case of mistaken identity. According to newspaper accounts of the time, a miner named

A view of the camp houses at Arjay, Kentucky, circa 1900. *From* Pictorial History of Middlesboro and the American Association Land Companies in Mingo Hollow.

George Marler was owed nine dollars by a gentleman identified only as Mr. Long. The debt was garnisheed, but Marler demanded the money from Long, threatening to kill him if he did not pay. George hired his brother, Bob Marler, to kill Long.

Bob Marler, knowing that Long had gone to Middlesborough to swear out a peace warrant for George, laid his plans to carry out the deed. He assumed that Long would be returning to Bennett's Fork on Monday, August 28, by the Belt Line train. Marler and an accomplice, Jim Wagner, hid in the bushes along the railroad in Bennett's Fork. They had cleared some of the brush in order to give a clear view of the train, and Marler had notched a small tree to make a resting place for his rifle, to ensure better aim. When the train slowed to a stop, a shot rang out, grazing conductor John Chapman's head. The bullet then struck Mrs. Mary Bowden, who was seated near the front of the train with her three small daughters. Shot through the liver, Mrs. Bowden slumped in her seat. Carried to a nearby home, Mrs. Bowden lingered near death for three days, expiring at 6:15 p.m. the Wednesday following the shooting.

The assailants had fled the scene but were arrested later on the morning of the shooting by Sheriff John C. Colson, Middlesborough Police Chief Conway and officers Will Nolan, S.A. Ball and John Turner. Both Marler and Wagner were lodged in the Middlesborough City Jail awaiting an examining trial.

Mrs. Bowden's husband, Thomas, was employed at one of the mines on Bennett's Fork, and the emotions of his coworkers ran high following the shooting. Monday night about 180 miners arrived in Middlesborough intending to lynch Marler. The miners searched the sheriff's office and the jail, and the next morning they searched the Knoxville, Cumberland Gap and Louisville Railroad (KCG&L) train, but to no avail. According to the contemporary news accounts, "Colson outwitted them and saved his man," apparently taking Marler to the Bell County Jail in Pineville on Monday and returning him to the Middlesborough lockup on Tuesday night.

Jim Wagner was released on Tuesday, having convinced authorities that he was at the mine at the time of the shooting. Marler remained in jail, and after the death of Mrs. Bowden, the group of lynch-happy miners became even more agitated, so much so that Colson telegraphed the governor for troops to keep the peace until the examining trial. The governor replied that

Colson must exhaust all of his means before troops could be sent in. The sheriff wired back, "Have none, people are all for hanging." In view of this, the Alford Light Infantry was called out, and by Thursday night Marler was under their protection, as was Jim Wagner, who had been rearrested earlier Thursday. Wagner, upon his arrest the second time, confessed to his part in the killing, telling authorities that George Marler had hired Bob to do the shooting and that he (Wagner) and Bob met at the mine hoping to provide an alibi for themselves.

On Friday morning, Marler waived his examining trial and was removed to Pineville, where he was lodged in the Bell County Jail to await his trial. Justice was meted out much swifter in the nineteenth century; there were no long delays and legal maneuverings, and Marler came to trial less than two months after the shooting, at the October term of court. During the course of the trial, it was brought out that Bob had been hired by his brother to kill Long. It was also learned that Long bore a striking resemblance to the Belt Line conductor, John Chapman, and when the train arrived at Bennett's Fork, Marler mistook Chapman for his intended victim and fired the fatal shot. In due course, the jury returned a verdict of guilty and sentenced Marler to die by hanging. At the same term of court, but in a separate trial, George Marler was sentenced to life imprisonment for his part in the affair.

The date for the hanging was set for February 9, 1894, and would be the first legal execution to take place in the county.

Marler spent the next few months in the county jail and was reticent about receiving visitors. The week before his execution date, he allowed Reverend W.A. Borum of the Baptist church in Middlesborough to visit and was received into the Baptist faith. Not being allowed to remove the prisoner from the building, Reverend Borum baptized Marler in the jail's bathtub.

As the execution date approached, Sheriff Colson had the gallows built in the yard of the jail. He also specially ordered a rope for the hanging. It was six-eighths of an inch thick and was tested with a 200-pound weight. Marler weighed 180 pounds.

On the morning of February 9, Sheriff Colson took Marler the clothing he would wear for his execution. Marler's sisters were allowed to visit him in his cell, where he talked to them of salvation, telling them that he was certain he would go to heaven. While he talked with them, he was clad in the clothing the sheriff had brought: a dark suit with a three-button cutaway coat, white tie, brown socks and felt slippers.

A crowd of two thousand people had gathered in the Narrows to witness Marler's death, and shortly before 11:00 a.m., the sheriff led Marler to the scaffold. He climbed the stairs to the ten-foot-high platform with a firm

step and then paused to address the crowd. Marler did not make a public confession from the gallows, although the day before he had admitted to the killing when he told Sheriff Colson, "I'm sorry for killing the woman." From the platform he told the crowd, "I'm going to heaven and I know God is going to take me home. I want all of you to meet me there. This should be a warning to all sinners. I love you and forgive you all."

At 11:00 a.m., Sheriff Colson placed the black cap over Marler's head and secured the noose around his neck. The trap was sprung by Deputy Ingram. Marler dropped to his death; the fall did not break his neck and it took him thirteen minutes to die.

One eyewitness to the execution was J.C. Hogan, who grew up around the Yellow Creek Valley. A young boy in 1894, he recalled the hanging some fifty years later in a letter printed in H.H. Fuson's history of Bell County. Writing from Chattanooga, Tennessee, Hogan said, "I recall seeing Bob Marler hung. I was there. The people tore the high fence down, and when the trap fell, something hit me in the eye and almost blinded it."

Only one of Marler's sisters stayed to witness his death. After he was pronounced dead, she took possession of the body and it was buried later that day at Wasioto.

Sheriff Colson continued to serve for some years after the execution and was killed while in office. On June 1, 1897, he was called to break up a fight at a Middlesborough saloon. As he dismounted his horse in front of the saloon, he was shot in the back.

COAL CREATES NEW BOOM

The 1900s saw the county pulling further out of the depths of the depression of the past decade. On Straight Creek, the mines continued to operate, though they were now controlled by a new concern. The depression had left its mark on the original owner, Pine Mountain Iron and Coal Company, which was sold at public sale in 1896, eventually becoming the National Coal & Iron Company. With the Straight Creek properties, it acquired 1,500 acres of mineral and timberlands and 300 lots in the city of Pineville. The main office building had also been in Pineville and was converted to a hotel by Pine Mountain Iron and Coal. For a time it was used as the Theodore Harris Institute—a private school—by the president of National Coal & Iron.

Everywhere one looked there were new business ventures side by side with those that had withstood the depression. In Middlesborough, the New South Brewery and Ice Company had ridden out the hard times and was annually shipping over twenty-five thousand barrels of its products throughout the South. It also made regular shipments to northern cities such as Cincinnati and Chicago. Two of its most popular brands of beer were Pinnacle and Crystal Pale.

Beer was not the only alcoholic beverage being manufactured in the city. The Middlesboro Distilling Company opened in 1901 and by 1904 was producing a high grade of corn whiskey. That was the year this particular whiskey took the gold medal at the St. Louis World's Fair.

Libations aside, coal was still the moving force in the county in the early years of the new century. The largest mine in the Middlesborough coal district in 1905 was the Fork Ridge Coal and Coke Company. It featured electric motors to haul the coal cars to the tipple and provided some of the

The largest mine in the Middlesborough coal district in 1905 was the Fork Ridge Coal and Coke Company, featuring electric motors to haul the coal cars to the tipple and some of the better housing in the area, with enough camp houses to accommodate four hundred workmen and their families. *From* Pictorial History of Middlesboro and the American Association Land Companies in Mingo Hollow.

better housing in the area, with enough camp houses to accommodate four hundred workmen and their families. Although the actual mine was just across the Tennessee state line, the company's offices were in Middlesborough.

Another mine located across the border but with its offices in Middlesborough was the Nicholson Coal Company. This mine began operating in the spring of 1902 with a three-year contract with the Southern Railroad for fifteen thousand tons of coal per month.

Middlesborough, originally intended to ship iron ore and steel, was now the shipping point for virtually every coal company in the southern end of the county. One of the major shippers was the Manring Coal Exchange, opened by J.L. Manring in 1905. Manring's offices were in the stone front building on Twentieth Street first built for the Watts Steel Company.

Manring was also the first person in the city to own a car. In 1903, as he did not know how to drive, Manring had S.O. Gallagher, a local plumber, go with him to Knoxville, where he purchased an Oldsmobile for $675.

Gallagher drove it back to Middlesborough—top speed was twenty-five miles per hour—and eventually Manring learned to operate the Olds himself.

Stony Fork was the other mining enclave leading out of Middlesboro to the east. There were three major operations on Stony Fork after the turn of the century. First of these was the Sagamore Coal Company at Logmont, Kentucky. It maintained five hundred acres, on which were located three seams of coal ranging in thickness from forty-two to sixty inches.

Quick to follow Sagamore in the Stony Fork area was Luke and Drummond Coal Company. This operation was begun by two men who had started their career as laborers in area mines—George Luke and Hugh Drummond. In 1904, they were producing 150 tons per day.

The third mine was Stony Fork Coal Company, opened by none other than John Ralston, who had begun the first mine on Bennett's Fork while Middlesborough was still in the planning stages. Quick to see the value of the Stony Fork property, by 1904 Ralston was producing two hundred tons per day at Stony Fork, all of it presold.

Moving in the other direction from Middlesborough toward the county seat along the old Wilderness Trail, other mines were quickly coming into their own. Just out of Middlesborough, close to where the old Rosa Drive-In Theatre was located, was Excelsior Mines and mining camp. Across Yellow Creek, one could find Low Ash mine and camp as well as the Mary Moore mine. The coal from Excelsior was transported across Yellow Creek by suspended cable cars to the tipple at Low Ash.

With the new boom of coal mining, Middlesborough was again becoming a prosperous city. Stores once again lined Cumberland Avenue. The banks returned, but now a little more conservative than in the first boom of the city. The Citizens State Bank, with deposits of $77,914.25, prided itself on that conservatism, stating, "The strength of a bank lies more in conservative management…This bank confines itself to a strictly legitimate banking business and will not take speculative risks for the sake of earning a possible return." Its board of directors listed two of the more prominent businessmen in town, W.H. Nicholson and J.L. Manring.

On the northern end of the county in Pineville, the sudden growth in coal mining was having its effects as well. The L&N now had a depot in town, running a steady stream of trains laden with coal and passengers several times a day. Banks were numerous, and everywhere one looked, new businesses were sprouting.

The Edwards Hotel, a favorite stopping place for travelers, was flourishing on Pine Street. There was also the new electric light plant close by, located in the building that would later become the Kentucky Utilities Storeroom.

The newest bank in town was First State, begun in 1899 by George H. Reese, formerly a cashier at Rice State Bank. First State Bank's first home was a small red brick building at the corner of Virginia Avenue and Pine Street. This was a prime location, as the majority of traffic through town passed the corner all through the day, the post office and the railroad depot being nearby.

Just after the turn of the century, in 1904, another bank came to town. The Bell National Bank, at the corner of Kentucky Avenue and Pine Street, brought the total of banks to five. The others were First State, People's, Pineville Bank and Rice State Bank. George Reese III, grandson of First State Bank's founder, says that his grandfather began his banking career in Pineville while working for Rice State Bank, then located in a house on Kentucky Avenue in the block just past Cherry Street toward the river. According to Reese, the house featured a bay window and business transactions were conducted from the street through this window.

What might be termed the New Pineville Hotel began operations about the same time as Bell National Bank. In recent years, the hotel had been used by the Theodore Harris Institute. Seeing a need for more hotels in the growing town, a group of businessmen formed the Pineville Investment Association and returned the property to its former use as a hotel. The property had originally been owned by Pine Mountain Iron and Coal Company.

Although Pineville was showing some growth, the real developments were in the nearby hollows and valleys. As it was outside of Middlesborough, coal was quickly becoming the number one industry outside Pineville as well. South of Pineville, along Clear Creek, a mine opened at Chenoa, Kentucky. The Chenoa Coal Company was just one of several in that area; others were Caney Creek, Poplar-Hignite, Clear Creek, Kelly and Cairnes.

North of Pineville along Greasy Creek lay the Blue Gem, Jellico and Dean seams of coal. The value of these seams had been known for quite some time, but the cost of building a railroad across the Cumberland River from Fourmile to give access to them had prohibited much work in the area. In 1904, the Bell Jellico Coal Company was formed with an eye toward accessing these seams. With a capital stock of $100,000, this company, under the leadership of A.C. Blowers, built a 210-foot bridge, 500 feet of trestle and 2¼ miles of railroad to its new mine. With this venture, it opened the area for other property and lease holders to develop their interests along Greasy Creek.

Everywhere one looked in the county, new communities and mines were springing up. Halfway between Pineville and Harlan, on Tom's Creek not far from where it joins the Cumberland River, the Southern Mining Company

This 1907 view of Pineville, by Robert Asher, was taken from near Flag Rock in the Narrows. The fledgling town is still spreading into the bottomland around the old Cumberland Ford. The lighter strip of land along the river was a sandy beach constructed by locals for a swimming area. *Author's collection.*

Mining has been a mainstay of the Bell County economy since the 1800s. This tipple, from about 1908, was at the Chenoa Coal Company operation on Kentucky Highway 190. *From* Pictorial History of Middlesboro and the American Association Land Companies in Mingo Hollow.

began the town of Balkan. Balkan was a fair-sized community sporting a large brick commissary and a community center. One custom unique to Balkan was the white paper, a practice organized before there were any types of hospitalization programs. When a miner at Balkan became ill or was injured and unable to work, his fellow miners signed a sheet of paper allowing the company to deduct the equivalent of a day's wages each month to support the injured worker until he could return to work.

Farther up the river, the community of Burchfield developed, named after the mine owner, William Burchfield. Burchfield was later renamed Cardinal after the coal company changed hands and was reorganized as the Kentucky Cardinal Coal Company. Cardinal is the name still used by the community today.

Nearby was the community of Blackmont. Before the bridge across the river was built, one had to ford the stream or use the Blackmont Ferry operated by Warren Keyes. Both of these communities flourished, especially after the rail line was extended into Harlan County.

Along the left fork of Straight Creek, various mines opened. There was a large coal camp at Cary operated by the Cary-Glendon Coal Company. Other mines in the area were at Big Hill (Blanche), Arjay, Rella, Fields, Red Bird and Crockett.

On the other fork was located, in addition to Straight Creek, the Pioneer Coal Company at Kettle Island. Kettle Island was originally named Locke for one of the pioneer families that had settled there but later was renamed Kettle Island because of the shape of an island in the creek leading to the community. Another version of the Kettle Island name is that early settlers discovered an iron kettle left on an island by previous explorers of the area.

The area around Colmar had been settled by some of the earliest pioneers and now the coal under its earth began to be developed. The Colmar mining camp was begun about 1914 by the Southern Mining Company.

Mining operations were also beginning at Fourmile Hollow with the opening of a mine at Rim, Kentucky.

One man alone may be credited with making the mines along the Cumberland River toward Harlan possible. Since 1890, T.J. Asher had been buying coal properties all along the river into Harlan County. By 1910, he owned over thirty-five thousand acres, but there was no way to get the coal out. The L&N had originally planned a line to Harlan in the 1880s but had switched its route to Norton, Virginia, by way of Middlesborough after that city was planned. Asher appealed to the L&N to build a line into Harlan County that would connect with the present L&N line at Wasioto. L&N told him that it was not interested; that such a line would be cost prohibitive.

Calling on his pioneer spirit, Asher formed the Wasioto and Black Mountain Railroad. He then created a construction company with John Hill Bailey and set it to the task of building the rail line into Harlan County. Seeing that the railroad into Harlan was becoming a reality, L&N approached Asher with the idea of purchasing it. The railroad audited the Wasioto and Black Mountain's books and discovered that it was building the line at a cost much lower than what L&N could do the job for, so it hired Asher to complete the job on behalf of L&N.

GROWTH CONTINUES

By 1907, the Pineville Independent School Board realized the need for a school to serve the African American community and established classes for it in the old school building in the Narrows. The first senior class graduated Pineville Graded School in 1908.

Churches, some of which had begun in private homes a decade or so before, were now filling the town. Represented were the Roman Catholic Church, the Christian Church (Disciples of Christ), the Methodist Episcopal Church, the Presbyterian Church and the Baptist Church.

There were numerous businesses. At the rear of the Burchfield department store at the corner of Pine Street and Kentucky Avenue was the livery stable of C.T. Samuels. This was a favorite gathering place for the "loafers and storytellers" of the day. A block away, at the corner of Cherry Street, was the Euster Brothers store and the Bowman Brothers Hardware. Gragg's Drugstore, located on Kentucky Avenue, was operating, as was the City Drugstore.

Pineville's oldest extant business began around the turn of the century. Brownlee & Arnett Hardware opened in a building on the block of Kentucky Avenue between Pine and Cherry Streets. By 1902, N.T. Arnett decided he wanted a business of his own, and he opened a store carrying a line of quality work clothes and dry goods. He also fulfilled another need of the community by stocking coffins. Eventually, the coffin business turned into full-fledged funeral services and Arnett attended the Cincinnati College of Embalming in 1907, becoming the first licensed embalmer and funeral director in Bell County. In a few short years, he moved the funeral business to a two-story building on Pine Street, keeping the dry goods store downstairs. This became Pineville's first funeral home, and he eventually added a third story to the structure and installed the first passenger elevator in town.

The block of Pine Street facing the courthouse had remained empty since the 1890 cyclone but was now beginning to erupt into a street of business buildings. This block had been used pretty much as a setting for the summertime activities of Chautauquas, minstrel shows and small carnivals but was now giving over to the business interests. One of the first buildings erected was the Broughton Building. Built in 1908 at a cost of $6,000, this structure, at the corner of Kentucky Avenue and Pine Street, was built to house a store on the ground floor with apartments on the second story.

On the block at the corner of Tennessee Avenue and Pine Street was a long, low building, very much in evidence in old photographs. In an interview in the 1970s, Grace Haley, née Johnson, a longtime resident of Pineville, said that this building was "where we had the sporting events, like roller skating."

About this same time, according to an item in the *Pineville Sun*, "a group of young ladies and gentlemen have organized a bathing club. They will erect a bath house just back of Mrs. Short's residence on the river bank." Mrs. Haley recalled this, stating that the white sand for the beach area along the riverbank was "hauled in by Ed Samuels and George Reese."

Across the county, Middlesborough was also following its need to grow as more and more businesses came to town. In 1900, the Excelsior Bottling Works opened at Twenty-second and Rochester; this was followed by Coca-Cola in 1904. R.M. Barry began bottling Coca-Cola in the back of a candy store at Twenty-first Street and Cumberland Avenue. After bottling the drink in the morning, he would deliver it to the mines around Middlesborough in the afternoon.

By 1910, Pepsi-Cola had a bottling works in the city as well. In 1911, a steam laundry opened near the bridge on North Nineteenth Street. The year 1911 also saw the coming of the Middlesboro Flour Mill, which offered Kentucky Bell, Mountain Queen and Fancy Queen flours. This mill was located on Fitzpatrick Avenue.

One of the earliest funeral homes in Middlesborough, Gibson Funeral Home, opened in 1905 at the east end of Cumberland Avenue.

More banks were also coming to the Magic City. In 1910, First State Bank opened for deposits on January 1. This bank was in the block of Cumberland Avenue between Nineteenth and Twentieth Streets, on the south side of the street.

Automobiles were also starting to become numerous in the city, and Middlesborough's first auto repair garage opened in 1908. The work on the vehicles was done by blacksmiths.

Two of Middlesborough's theatres opened in 1911—the Amuzu and the Manring. The Manring was located on Cumberland Avenue in the now

Fountain Square in Middlesborough, about 1900. The Fountain Square section of the city was the main shopping area of the time. *Author's collection.*

vacant lot at the corner of Twenty-first Street and Cumberland Avenue. With the Opera House, built during the first boom, these theatres provided the majority of the entertainment for local residents. Along with the silent movies of the day, these entertainments ranged from Shakespearean drama to the traveling vaudeville shows.

Another form of entertainment for the young and affluent of the city was an afternoon of golf. The Middlesborough Country Club was first organized by the city's English founders in 1890 and is now promoted as the second-oldest golf course in the country. Or there might be an afternoon of swimming and boating at Fern Lake followed by an evening of dinner and dancing.

Though entertainment may have been scarce in the outlying area, business was not. Mining was the industry of the day, and with it came related businesses. In the Morgan Hollow area of Laurel Fork there were thirteen stores operating at one time. Among these, with their owners, were: a meat market, Susie Morgan; general store, J.P. and Susie Morgan; grocery stores, Ike Frazier, Joe Rose, Ed Morgan and Gertrude Drinnon; dry goods stores, Wayland Smith, [unknown] Wender and Bill Morgan; shoe store, Sol Garber; hardware and furniture, Dewey Morgan and Earl Morgan; restaurant, Earl Morgan; liquor store/pool hall; barbershop; coffin and hay store, J.P. Morgan; beauty shop, Myrtle Morgan; and ten-cent store, Earl Morgan.

This cabin was the home of Willie Gibbons. It was located at Hensley's Settlement, an isolated, self-sufficient community located on Brush Mountain. Hensley's Settlement is now part of Cumberland Gap National Historical Park. The Gibbons cabin was destroyed a few years ago by arsonists. *Author's collection.*

Soon after the turn of the century, a community began on Brush Mountain that has been acclaimed nationally as a "self-contained" community. In 1903, Sherman Hensley and his wife, Nicey Ann, along with two children, moved to the top of Brush Mountain (part of the rugged Cumberland Mountain Range). There were no roads into the community; travel was by mule and mule-drawn sledge over steep, rugged trails. Hensley later inherited some six hundred acres of Brush Mountain from his father-in-law, and there he remained for forty-eight years with no telephones, no roads, no electricity, no motor-driven vehicles and no modern appliances. Not long after Hensley homesteaded what was to become known as Hensley's Settlement, others began to join him and his family in this mountain wilderness.

MINE ACCIDENTS AND ECONOMIC WOES

O f course, as with any business, the mining industry brought with it its share of misfortunes. Through the years there would be many deaths and injuries from mine and mine-related accidents. One of the first of these occurred at Fourmile. At the head of Fourmile Hollow was a small community called Rim. It was there that the Continental Coal Company's Rim No. 4 mine was located.

On Friday, September 12, 1921, seventy-six kegs of black powder exploded inside the mine, claiming the lives of two men. Apparently, the powder was being moved in mine cars from the "knuckle" of No. 4 to the mouth of the mine. Mine foreman Joe Lewis was sitting atop the kegs in the third car, and car-coupler Clay Johnston was standing next to the car closest to the motor. Johnston gave motorman Dave Disney the okay to "highball," and when Disney turned on the current the explosion followed. Some witnesses claimed to have heard three distinct reports, while others claimed that there weren't as many.

The force of the blast threw Johnston about thirty feet from where he had been standing. When other workers reached him, they had to tear the burning clothes from his body before they could remove him from the mine. He was conscious when he was taken from the accident scene and carried to his home nearby; however, contemporary reports stated that he "suffered horribly and died about 9:30 that night."

Lewis, the mine foreman, was thrown about fifty feet by the explosion. When found, his clothes were also in flames but were extinguished by his rescuers. Lewis was taken to the newly opened Continental Miners Hospital in Pineville, where it was first thought that he would survive. However, following complications, he died about 9:00 p.m.

Motorman Disney, though badly burned around the head and shoulders, recovered. Apparently the motor itself protected him from the main blast.

The hospital mentioned above was the first such institution in Pineville. It had just opened a few months before the Rim accident, after Continental Coal bought the Ed Blair home on Pine Street for use as a hospital. This two-story frame house was originally built as the residence of Napoleon Bonaparte Hayes and sat about where the present-day U.S. 25E intersects Pine Street. In 1914, Continental Miners moved to a two-story frame building on Cherry Street and was under the management of Rice Johnson. The hospital remained at the location until the building burned down in 1930.

One barometer of how the mines were doing was to observe the tobacco purchases at the company store. When times were good, most people bought name brands such as Camel or Lucky Strike. In leaner times, they either bought Prince Albert and rolled their own cigarettes or—if they opted to stay with the "tailor mades"—switched to the "off brands" such as Wings or Avalon.

From the onset of coal mining in Bell County in the late 1800s through the early years of the twentieth century, times—for the most part—were good. The mines were producing, the men were being paid and the economy benefited. And things would take even more of an upswing with the coming of the World War.

IMPROVING ROADS AND
THE LAST HANGING

The decade from 1910 through 1919 was a busy one for Bell County. The mines were working full force and the timber business was still a main industry.

T.J. Asher & Sons was still the largest lumber shipper in the area; timber cut upstream from Wasioto, all the way into Harlan County, was floated downstream on the Cumberland to be processed and shipped from the Asher mill. But Asher's foray into railroad building in the last decade, along with the acquisition of several prime mineral properties, was about to change the face of the Asher family business.

Once the railroad line had been extended along the Cumberland River past Hance's Creek, Asher began his first venture into the mining business. There is a seam of coal along Hance's ridge called the Hance Seam. Here he opened his first mine, which he named Varilla, after his wife. As the mine at Varilla had only tapped a small portion of the property Asher held, he rethought his role in the coal industry and decided that he could best serve and benefit by becoming a coal land–leasing company, supplying the land, the coal, the camp town and the timbers for supports in the mines. Now comfortable with what course its enterprise was taking, the Asher company quickly opened mines at Whipple, Balkan and Colmar in Bell County, with several other locations in neighboring Harlan County.

By 1914, the company had reorganized as the Asher Coal Mining Company and had located in the Asher Building offices in Pineville at the corner of Virginia Avenue and Walnut Street.

About the time he was reorganizing his company, T.J. Asher entered into the political arena in Bell County and was elected county judge in 1914. Seeing that Bell County had taxable properties of from $10 to $16 million,

T.J. Asher operated this sawmill at Wasioto, Kentucky. This mill was the basis of today's Asher Land and Mineral, Ltd. *Author's collection.*

This photo shows the swinging bridge spanning the Cumberland River, connecting old U.S. Highway 119 with Varilla Coal Mine camp. *From* Pictorial History of Middlesboro and the American Association Land Companies in Mingo Hollow.

T.J. Asher came to Wasioto as a logger, but he quickly rose to prominence in the coal and timber business. He parlayed a sawmill along the banks of the Cumberland River into a coal, land and timber empire that still operates today as Asher Land and Mineral, Ltd. *From* Asher, A Family History.

Asher was quick to point out that the county could improve roadways in any direction, rivers and mountains being no obstacle to progress. The citizens were supportive, and a bond issue was floated to provide $250 million for road construction.

One problem faced in road construction was what to do about the large number of streams to be crossed. Every stream in the county was prone to flooding in the rainy season, which could destroy wooden bridges. Asher solved that problem by buying several used steel railroad bridges. These proved to be cheaper and stronger than the usual lightweight steel or concrete bridges normally used in road building.

The decade not only saw Bell County advance in roadways and political leadership, but it also saw a change in the way condemned prisoners were executed. The last public execution in the county took place in 1911; from that date on all executions were performed at the state prison.

The last person to be executed in Bell County was James White, a nineteen-year-old black man from Middlesborough, who met his death by hanging seventeen years after the first legal hanging in the county.

James White was the last person to be legally hanged in Bell County. He was convicted of raping an eight-year-old Middlesborough girl. *Courtesy of Anna Mae Brock.*

On Thursday, July 29, 1909, White, originally from Williamsburg, Kentucky, was arrested and charged with the rape of Mossie Woodward, an eight-year-old Middlesborough girl. At the time, White was seventeen years old.

The young girl, in the company of a younger sister, was on her way to a neighbor's house when White accosted her on Twenty-second Street. The younger sister ran home to tell her mother and when they returned White had fled, leaving the older girl in tears.

A posse was quickly formed, and White was arrested about two hours later. Officials quickly transported White to the county jail in Pineville for safekeeping, as the emotions of Middlesborough residents were running high and it was feared that the prisoner would be mobbed. The next night, Jailer Robert VanBever received word that a mob was on its way from Middlesborough intent on lynching White. The 11:00 p.m. train arrived at the Pineville Depot across the river from Kentucky Avenue and fifty heavily armed men alighted. They proceeded to the jail on Virginia Avenue, where they demanded that VanBever turn White over to them. The jailer told them that White was on his way to Richmond, Kentucky, for safekeeping.

Upon learning that the mob was coming for White, VanBever had taken White to the Wallsend Station, and by the time the would-be lynchers arrived

at the jail, the prisoner was on his way to Richmond aboard the same train that had brought them from Middlesborough.

Not convinced that White was no longer in the jail, the leader of the mob was allowed to look through the building. Not finding White on the premises, he was still skeptical, and several homes in Pineville were searched before the mob was convinced that the prisoner was no longer in town.

White remained in Richmond until the September term of court, when he entered a plea of guilty before Judge M.J. Moss. The jury failed to reach a verdict; eleven were in favor of death and one juror held out for life imprisonment. White was given another trial at the same term of court, this time changing his plea to not guilty. Again, the jurors were unable to return a verdict, with the vote the same as at the previous trial. White was returned to Richmond to await the January term of court.

At the January term, White entered a plea of not guilty before Special Judge Watt Hardin. Hardin had been selected to try the case, as newly elected Bell Circuit Judge Davis had to recuse himself since he had assisted the prosecution during the first two trials.

After hearing the evidence, the jurors this time were unanimous in their decision: death. The sentence was signed by Jury Foreman John C. Green. The execution was set for March 23, 1910. A stay of execution was granted while White's case was appealed. The lower court's decision was upheld and the new death date was set for December 12, 1910. Twice the governor was asked to commute White's sentence, resulting in further delays, but the final execution date was set for Monday, January 30, 1911. White was to be hanged by the neck until dead from a scaffold constructed in the rear yard of the Bell County Jail. Sheriff Robert VanBever, who had been jailer when White was arrested, had the scaffold erected behind a twenty-foot-high wooden fence, as the execution was to take place away from the public view. The scaffold was built by J.F. Underwood and J.B. Roark.

The fateful date arrived, and early that morning, people began arriving in Pineville hoping to view the execution from the rooftops of surrounding buildings or by climbing nearby telephone poles.

Before a crowd of fifty people who had been admitted to the enclosure by ticket and hundreds of others who watched from nearby roofs—the straps were fastened about White's arms and ankles. Sheriff VanBever then asked if he wished to make a statement.

White told those assembled that he was not guilty of the crime and did not think that he had been treated fairly by the courts and ought not to hang. He also said that he did not want either Sheriff VanBever or Deputy Sheriffs John McCoy or John Wilson to hang him; he instead requested that the trap

be sprung by Jailer Rufus Wilson. Wilson refused the request, and White then asked that Deputy Sheriff Joe Manning perform the task.

A rope was placed around White's neck, the black cap was adjusted over his head and Deputy Manning stepped forward to the lever that controlled the trap, saying, "May the Lord have mercy on your soul." He pulled the lever and White dropped through the trap at 10:37 a.m.

The drop did not break White's neck and he strangled to death. After fifteen minutes, Coroner W.K. Evans, a Middlesborough physician, pronounced the prisoner dead. The coffin in which White was to be buried was beneath the scaffold, and his body was taken down and placed in it. When this had been done, Sheriff VanBever opened the fence, allowing onlookers to file in for a look at the body.

According to a contemporary newspaper account, it was reported by the coroner that White's death was "a painless one, as there was no contractions of the limbs, such as usual indicate suffering."

By his death, White entered the annals of Bell County history as the second and last person to be legally executed in the county. Following his death, all executions were carried out at the state prison, with the preferred method being electrocution.

WORLD WAR BRINGS ANOTHER BOOM

By the time America officially declared war on Germany on April 6, 1917, Bell County was fifty years old.

All of the major industries relied on coal to fire their furnaces as they manufactured goods for the war effort, and the eastern Kentucky coal fields became known throughout the world as the demand for the black mineral was met.

For the most part, mining had been a younger man's profession; the labor was hard, digging coal out of a mountain with a pick and shovel while staying confined in a small, cramped space during the entire work shift. The dawning of the war brought about changes in the type of man who worked the mine and in the wages paid.

As more and more troops were sent overseas, some by draft but many by volunteering, a labor shortage was felt in the coal fields. Older miners were pressed upon to reenter the mines and contribute to the war needs. But still, there wasn't enough manpower. Wages were increased, at some mines to as much as ten dollars a day or more, to entice those men who had disdained work underground, choosing instead to tend to their rocky mountainside farms. Although many of them had said that they would never enter a mine, preferring the life of their farmer forefathers, the lack of ready cash from farming made the appeal of the mine money too great.

And, as with every boom in the coal industry, related businesses flourished during the war years. Both in Pineville and Middlesborough, streets were lined with every type of store conceivable—from sweet shops to automobile dealerships.

Minnie Price, who first came to Pineville in 1916 at the age of twenty-four, recalled the town during those boom years of the war. In a 1977 interview for the Oral History Project, she said:

> *Pineville was a boom, Honey. Plenty of money and plenty of work. Everybody was workin'. Happy, workin' makin' their own livin'. And trains was running in and out…There was buses that run back and forth, carryin' passengers. Pineville Hotel and Continental Hotel* [built in 1915 at the corner of Walnut Street and Virginia Avenue and razed during the 1970s for a parking lot].
>
> *The streets wasn't paved here in Pineville when I first come…Down in here where Mr. Ray Moss lives* [Pine Street, now occupied by the Farmer Helton Judicial Building] *was a lumberyard, or somethin'. It's just a swamp.* [The sidewalks] *weren't concreted like they are now. I guess they's just rocks or brick or somethin'. You know I was young back then, I wasn't paying much attention to what the sidewalks were.*

Bell County did its share in the war, sending hundreds of its young men to a world far removed from the isolated hills in which they had been born. Those from Bell County who died during the war were John Anderson,

The Continental Hotel was long a mainstay of the court square in Pineville. Built in 1915, the hotel stood until 1970, when it was razed to make space for a city parking lot. *Author's collection.*

David B. Asher, George Barnett, Fred Bruce, Alex Collett, Clifford Dozier, Joe Gibson, Dewey J. Guy, Abel Harbin, John D. Hensley, Soloman Lee, Julian McKenney, Press Miller, James Noe, Burrell Smith, Frontis H. Smith, Chester Smith and Anderson Wells.

Of those who fell during the war, two names have been preserved by local American Legion posts. The Bennett Asher Post, named for David B. Asher, is in Pineville, and the Dewey Guy Post is in Middlesboro. Guy, a native of Middlesborough, was the first from Bell County to die in the war. He was fatally wounded July 3, 1918.

As the war came to a close, those young men from Bell County who only a few months before had been thrust upon foreign shores returned to their hillside homes, and to their former professions. Many returned to the mines, others to their farms or "town jobs." But as with the rest of the nation, Bell County was facing a postwar recession. Another boom was fading.

When former doughboys picked up their picks and shovels and headed for the mines, they were no longer looking at the double-digit wages of the war years. With peace declared, the huge demand for coal dropped to that needed before the war. Wages dropped as well. Men were now fortunate to be paid $1.50 per day. However, the need for coal was still present throughout the nation, and the mines and miners survived and gradually increased their incomes as the 1920s progressed.

The returning veterans also saw many changes in their choice of recreation spots in Pineville and Middlesborough. Gone was the multitude of saloons lining the streets of both cities. While the war was being waged in Europe, the U.S. Congress had enacted the Volstead Act. Prohibition was here to stay—at least for the next several years.

With the coming of Prohibition, two of Middlesborough's leading businesses were now closed—the Middlesboro Distilling Company and the New South Brewery both ceased operation when the act became law.

Of course, the mere fact that manufacturing, drinking or selling alcoholic beverages was illegal did not really affect those Bell Countians with a thirst. As in the rest of the nation, bootlegging flourished. And the hollows that had once contained small stills for a family's own manufacture of moonshine now became suppliers to a more public clientele. Moonshining was not the only avocation available, at least not for Henry Harrison Mayes. Mayes, who moved from Tazewell, Tennessee, to Middlesborough with his family shortly after his birth in 1898, literally took up his cross in 1918.

That was the year that Mayes began creating 1,400-pound concrete crosses or hearts to erect along the sides of roadways throughout the country. Those hearts and crosses, now familiar to hundreds of thousands of motorists, bear

The Bell County Courthouse in Pineville, Kentucky, was destroyed by fire June 14, 1918. At the time, there were rumors of arson but nothing was ever proved. *Author's collection.*

inscriptions such as "Jesus Is Coming Soon" and "Prepare to Meet God." Mayes is also responsible for many of the hand-lettered signs on corrugated metal that dot the roadsides nationwide.

"I guess I was 14 or 15 when I first started organizing Sunday Schools and prayer meetings," Mayes once told a reporter. "I started writing small signs

on rough paper and tacked them to poles. Then I started painting them on rocks. From there I moved to bigger things."

"I'm determined to have a sign in all the states of the Union, all the continents, the bottom of every ocean and all the planets," Mayes once said. At last count, his concrete signs are in forty-four states. Mayes continued his sign work for nearly seventy years, traveling throughout the country in his spare time to erect the crosses, using for the most part his own funds for the labor of love.

One major change in appearance faced those returning to the city of Pineville: the courthouse was gone! The old building, which had served since the town was incorporated, had burned down on June 14, 1918. The fire completely destroyed the stone building; many residents watched the blaze from safe distances until the clock fell, signaling the collapse of the structure. The rubble of the old building was cleared away, and plans were made for a new, bigger facility, which was completed some four years later.

EDUCATION IMPROVES IN THE '20S

The decade of the 1920s was an important one in terms of education for most of Bell County. Improvements were made to the school systems in Middlesborough and Pineville, Clear Creek Mountain Preacher's School began, Henderson Settlement was founded and Red Bird saw the arrival of one of its most promising leaders in the educational field.

In Middlesborough, J.W. Bradner had been appointed superintendent of schools. He was quick to secure the passage of a $150,000 bond issue to build four schools: one each in East End, Junction, Noetown and Binghamtown. He also secured a new high school facility. In all, he brought funds totaling nearly half a million dollars into the system to improve facilities and the quality of education. It was also in the 1920s that the Middlesborough schools began their football program, fielding their first team in 1922. The football stadium is named Bradner Stadium in honor of the superintendent.

Across the county in Pineville, school improvements begun in the '10s were being completed in the 1920s. By 1917, the high school had outgrown the facility on Tennessee Avenue and it had moved into a new building on Virginia Avenue between Laurel and Holly Streets. About this same time, plans were laid for a new facility for the African American students in the city, and until a building for them could be constructed, they used the old Tennessee Avenue facility. Finally, in the 1920s, the first permanent school for African American students was completed. Roland Hayes School was located at the corner of Tennessee Avenue and Mountain View Avenue and served the black community until the schools were integrated in the 1950s.

It was also in the 1920s that a seven-classroom wing was added to the Virginia Avenue building. This wing contained a gymnasium and a large study hall as well.

As with neighboring Middlesborough, Pineville fielded its first football team in 1922. The football field, one block north of the school at the end of Catalpa Street, was purchased in 1929 and subsequently named Samuels Field to honor Ed Samuels, one of the earliest supporters of athletics in the community.

But the two cities were not alone in meeting educational needs for Bell Countians. In 1921, Reverend John H. DeWall became the first superintendent of Red Bird Settlement School. This school was begun by the Evangelical Church, which, as the Evangelical United Brethren, would merge in 1968 with the Methodist Church to become the United Methodist Church. The church had been hoping to establish a mission and school in "the most needed place," and the section where Bell, Clay and Leslie Counties meet was chosen. The area is named Beverly, but because of its association with the school, the name Red Bird is used interchangeably.

DeWall arrived in September 1921 and began to erect the buildings needed for the school. The first teachers—Myra Bowman and Emaline Welsh—preceded DeWall, arriving in July 1921.

Throughout the 1920s, the only high schools in the county were those in Pineville and Middlesborough, but at the Red Bird high school work began in 1922 with six students. By the following year, there were sixteen students studying at the high school level. By 1923, a dormitory had been constructed and housed thirty-four students, both boys and girls. In 1926, a new high school building was erected and the old building was converted to a boys' dormitory. Students in both dormitories now numbered seventy-two.

It was also in 1923 that the foundation of the Red Bird medical facilities began. That year saw the arrival of Miss Lydia B. Rice, a nurse who joined the Red Bird Mission staff. Nurse Rice treated all cases—simple to complex. In 1927, Dr. Harlan Helm came to Red Bird, and by November 5, 1928, the Red Bird Hospital was dedicated. The first surgery was performed two days later.

On the other side of the county, in the rugged area known as South America, Methodist minister Hiram Milo Frakes was beginning an undertaking to bring education and salvation to the people of this still remote and rugged area. One February day in 1925, Reverend Frakes heard a judge in Pineville dismiss a case because the independent mountaineers from South America wouldn't testify "agin" one another. Intrigued and challenged by this area and its people, Frakes rode a mule the six miles from Chenoa (the last train stop) and found Billy Partin, who served as his guide as he searched for a site for a mission.

Preaching his first sermon in the area on October 5, 1925, Frakes made an appeal for land and money to build a school for the residents. He

met with great success, and from that humble beginning the Henderson Settlement mission began. Henderson Settlement was the name chosen to honor both Bishop Theodore S. Henderson, who had approved Frakes's plan for the mission, and Bill Henderson, who had donated his entire farm for the project. The first school met in Bill Henderson's old log cabin and consisted of thirteen students taught by Deaconess Bertha Riel.

A few miles closer to Pineville down Clear Creek, another preacher with another dream was also active during the 1920s. The area known as Clear Creek Springs had been touted for its waters since the early settlement days of the county. The property was originally owned by the Reazler family and had at first been promoted for the curative powers of its waters, which have a strong sulfur content with a distinctive egg taste and odor. Mrs. Sarah Davis, a daughter of Reazler's, had inherited the property, and she and her husband, J.M.C. Davis, had homesteaded it.

In the early 1920s, Dr. Lloyd C. Kelly came to Pineville as pastor of First Baptist Church. One of Reverend Kelly's hobbies was taking long walks in the surrounding mountains. He first saw Clear Creek on one of these excursions, and something about the area kept drawing him back.

Kelly had for years been concerned about the lack of training and formal education for mountain ministers. Having been overcome by the scenic beauty and the presence of God that he felt as he surveyed Clear Creek Valley, Kelly decided that it would be an opportune place to build a school to train ministers from all over, especially those native to the mountains. Garnering support from Baptists in both Pineville and Middlesborough, Kelly found that the property could be purchased from Mrs. Davis. In 1923, this group bought 450 acres for $14,000, and Clear Creek Mountain Preachers' School was born.

This started out as a two- or three-week summer encampment in which Kelly and a small faculty offered mountain preachers classes in Bible study. Over the next few years, these encampments grew, and finally a full-time, permanent school was begun, offering training for ministers far and wide who wished to come to Clear Creek to study.

The Bell County School System had no four-year high schools, offering grade school classes only. There were a few two-year high school programs, but these were located mainly around a few of the coal camps. If others of the seven thousand county students wished to attend high school, they had to do so at Pineville High School.

In the late 1920s, through the foresight of Jakie Howard and others, this was about to change. When Howard began as superintendent of the county schools in 1928, he brought with him a dream of a county high school.

He was a native Bell Countian, but he had been able to attend high school outside of southeastern Kentucky.

Howard convinced the school board to look at other high school buildings across the state. As a result of this, the board agreed to have a Barbourville architect draw plans for a county high school.

The land for the school—eventually to be known as the Howard Building—was located at East Pineville, just a few miles from Pineville along U.S. 119, and was purchased in March 1929. Actual construction of the school did not begin until 1930 and—built on a pay-as-you-go basis—it was not ready for classes until 1931, with students composed mainly of freshmen. There were a few sophomores and juniors but no seniors.

HOLLYWOOD COMES TO BELL COUNTY AND THE FIRST PARK IS CREATED

It was also in the 1920s that Hollywood came to Bell County. In 1920, Fox Film Company sent scouts to the area of Virginia, Kentucky and Tennessee to find suitable locations for filming Pearl White's next movie—a silent film to be based on Neville Buck's novel, *A Pagan of the Hills*, to be retitled *The Mountain Woman* for the screen. White was a well-known star of the silent era and was best known for her serial "meller drammers" such as *The Perils of Pauline*. Her costar in *The Mountain Woman* was Dick Travers.

Pineville and the mountainous area surrounding it were chosen for the film's location work, and the film crew and cast set up their base of operations at the Continental Hotel. Filming was done at several locations, including the overlook rock above Pineville, Log Mountain, Clear Creek, the Narrows, Puckett's Creek and Blacksnake. Several local people appeared as extras in the movie.

White entertained the local residents at various benefits during her stay in the area, but her most remembered activities during the filming were her exploits at the card table. White, from all reports no mean hand with a deck of cards, took some of the city fathers to the cleaners while playing poker.

The film crew completed the production and moved on, but Miss White returned to Pineville the next year by way of the silver screen, when the film had its local premiere at the Gaines Theatre. The Gaines was located in the brownstone building on Kentucky Avenue behind the Masonic temple. The film reportedly met with hearty approval from locals who had watched it being made.

Although no known copies of the film have been found to date, one local resident does have a still photo—apparently a publicity still—from the film. Sandy Posey said that she got the photo from Arthur Howard, who lived on

the Asher Sawmill Road, and that he, in turn, had gotten it from his mother, who lived in the Clear Creek area at the time the film was being produced. The photo shows Miss White, dressed in a black slouch hat, standing behind a team of oxen. Posey said that Howard's mother claimed the photo was taken during filming along the Asher Sawmill Road.

Just as the Hollywood location scouts had seen the potential of the Bell County area, so did local residents and others throughout the state. In 1929, Bell County was chosen as the site of the first park in the Kentucky State Parks System. On 2,500 acres of Pine Mountain between Pineville and Clear Creek, Park No. 1, or Cumberland State Park, began operation on August 12, 1929. The initial 2,000 acres were donated by local residents and the additional 500 acres were obtained through the help of local businessmen. The park initially featured rugged trails leading to such sites as the Living Stairway, Rock Hotel and the Hemlock Gardens and proved to be a favorite picnic spot for locals as well as visitors to the area.

In 1920, Fox Studios brought a production company to Bell County to film *The Mountain Woman*, starring silent film star Pearl White. White is shown in a publicity still from the film. The photo was taken on Asher Sawmill Road just south of Pineville. *Courtesy Sandy Posey.*

The Herndon J. Evans Lodge at Pine Mountain State Resort Park shortly after completion. Note the stonemason's mortar box at lower right and a workman's ladder in front of the building. *Author's collection.*

Throughout the years, the first sight visitors often saw when approaching the park was a lake on the land formerly known as Moss Bottoms. Clear Creek was dammed to create this lake, which at various times was known as Pine Mountain Lake, Dr. Thomas Walker Lake, Bert T. Combs Lake and, most often, Lake Mistake.

At the beginning, the lake featured a pavilion where orchestras provided dance music on warm summer evenings. The pavilion was a two-story structure on pilings so that it extended over the water. Here one could rent one of a fleet of twenty-four boats. The daytime hours were spent swimming, boating and fishing. But as silt from Clear Creek kept filling in the lake, its scope and usage changed throughout the years, until in the 1970s it was drained and allowed to return to marshland, before being redesigned as part of Wasioto Winds Golf Course.

Prior to the state park's founding, a portion of it known today as Laurel Cove Amphitheatre had been called the Deer Park. This natural amphitheatre, just a mile or so off present U.S. 25E, has as its backdrop a towering rock cliff covered in mountain laurel.

Here Sill Browning would arrive daily to feed the many deer that inhabited the area at a barn-like feeding trough that the state had provided for them. Local residents who wished to see the deer, but not scare them off, would

climb to the top of the cliff and wait there until Browning arrived to perform his task.

Both Pineville and Middlesborough—and Bell County overall—were a hive of activity in the 1920s. Businesses were flourishing everywhere one looked, and on Saturdays the stores were filled with customers, often until late evening.

Paul Greene, a Pinevillian, grew up during the 1920s. In his series of booklets and newspaper columns, Greene recalled one enterprising business in Pineville that has never received much mention: the hamburger stand that was attached to the bridge leading to the passenger depot. This bridge spanned the river from Kentucky Avenue to the L&N Depot. According to Greene, M.H. Carter built the stand onto the first pier of the bridge as one crossed from the depot side. This was a logical location, as virtually all traffic in that pre-automotive age passed over the bridge with the arrival of each train. Greene wrote, "I can recall a menu of hamburgers, hot dogs, cold drinks and coffee was the main bill of fare and the traveling public jammed into the little place for a tasty bite while changing trains or going to and from the depot. The operator made it more attractive by checking your baggage for an extra piece of money. I recall the standard price of a sandwich was 10 cents with the drinks at 5 cents and a piece of baggage was checked for a dime." Carter sold the stand to A.H. Stroud and it eventually ceased business in the 1930s.

Middlesborough of the 1920s saw the coming of the air age. There had been a few brave pilots who attempted landings on dirt roadways and in fields in the mountains of Bell County after the Wright brothers' first flight in 1904, but it was not until 1921 that a permanent landing strip was created. Jack Colson, one of the first pilots in the area, created an airfield on Dorchester Avenue near Thirty-fourth Street. Colson was a proficient pilot and flew biplanes early in his career. By the time of World War II, he was to train pilots at the Middlesborough airport for the armed forces.

By 1946, a permanent Middlesboro–Bell County Airport Board was created to oversee the airport at the site of Colson's first field, and the first members were Dr. Adam Stacy, Dr. J.M. Brooks, Clyde Creech, H.A. McCamy, Fred Silhanek and Lee Campbell. Because of the steepness of the surrounding mountains, the airport designers were forced to orient the runway with the best available approach slopes rather than with the prevailing wind direction, as is the usual custom. The Middlesboro–Bell County Airport lies on about seventy acres and can accommodate small jets.

THE CRASH, KETTLE ISLAND MINE DISASTER AND UNION TROUBLE

The 1920s ended not with a whimper but with a crash—a crash that would have far-reaching implications over the next decade.

In October 1929, Wall Street, in the vernacular of the headlines of the show business paper *Variety*, "Laid an Egg." The stock market crash of that year did not at first affect the coal fields nor, for the most part, the common man, but as time passed and businesses began to fail, the crash was felt by everyone, and in Bell County every economic stratum was soon to realize this.

A saddened note—not related to the crash and the coming Great Depression—marked the beginning of the 1930s for Bell County. On March 28, 1930, the lives of sixteen miners were lost in one of the worst mining accidents in Bell County's history. The explosion happened about 2:00 p.m. on Saturday afternoon at the mine of Pioneer Coal Company at Kettle Island when only about twenty miners were working, or the results could have been far more devastating.

The workers were about two miles underground when the accident occurred, and all were killed by the deadly afterdamp, or carbon monoxide gas, that follows a mine blast. The force of the explosion was evidenced by the torn-out walls, ripped-up track and demolished brattices and trolley wires that were encountered by rescue workers attempting to reach the men inside. Rescue operations had begun immediately after the blast, but by early evening the day of the accident, those on the scene knew that it would take nothing less than a miracle to bring the miners out alive.

Rescue teams reported to the scene from throughout the eastern Kentucky coal fields and worked in shifts to try to recover the men, or their bodies. Seven area physicians were also on hand to render what aid they could, for the most part keeping close eyes on the rescue teams to ensure that they did not become victims as well. Those doctors were M.D. Hoskins, S.F. Gregory, E.W. Adkins, B.E. Giannini, P.E. Giannini, Charles B. Stacy and J.H. Hendren.

Those who perished in the explosion are listed here, with their dependents: Luther Hodge, wife; Mason Fultz, wife and eight children; John Engle, wife and four children; Adrian Helton, wife and three children; Elmer Steele, wife and three children; Raymond Simpson, wife; Harvey Allen, wife and eight children; Dave Souders, wife and one child; M.C. Vann, assistant foreman, wife and two children; J.E. Hill, foreman, wife and six children; Jesse Lasley, wife and two children; J.L. Jones, wife and five children; John L. Cox, wife and two children; Lee A. Johnson, wife and one child; Sam Profitt, wife and six children; and Ed Osborne, seventeen years old, single.

The Depression years also saw a renewed movement in unions in the coal-mining industry of the county. In the previous decade, there had been a decline in membership in the United Mine Workers of America (UMWA), due in part to internal struggles among the leadership and several failures to hold mine owners to contracts. In 1919, about 70 percent of all bituminous coal mined came from union mines, but by 1930 that had dropped to less than 20 percent; it was probably a great deal less than 20 percent in reality, as government statisticians demonstrated that was an inflated figure.

In 1931, the UMWA had attempted to organize in nearby Harlan County, but that resulted in the disastrous Battle of Evarts, and for all practical purposes the UMWA was dead in the eastern Kentucky coal fields. With the UMWA in turmoil, miners faced pay cuts as the Great Depression progressed and they were ready for the next union to come upon the scene. At first they didn't know—or didn't care—that the union might be Communist in its affiliation.

In the strictest sense, the National Miners Union (NMU) was not a union; at least not in the way that word is construed by most workers. Nor was it founded by miners. It had been created by the Communist Party in 1928 to become a dual union, attempting to lure the more militant workers away from other affiliations. The Communist Party had changed its tactics, no longer was it trying to infiltrate from within the American Federation of Labor unions (of which the UMWA was one). Now it would compete with its own brand of union.

In June 1931, Dan Singer, working under the name Dan Brooks, appeared in Bell County to organize the NMU in Bell, Harlan and Knox Counties in Kentucky and in eastern Tennessee. Blacklisted and unemployed miners quickly flocked to the NMU's banner.

One of the first mass meetings in Bell County was at Arjay in August 1931, and a short while later the Workers International Relief (a unit of the Communist Party) set up a soup kitchen in the Missionary Baptist Church there to help feed the miners and their families. By mid-fall, there were a number of NMU locals on both forks of Straight Creek.

For the rest of 1931 and most of 1932, the NMU organized several wildcat strikes at various mines in the county, the most notable being at Glendon, a small coal camp downstream from Arjay. These strikes resulted in some arrests being made among the miners, and the International Labor Defense came into the area to offer aid to those who had been jailed.

A few months after Harlan County's Battle of Evarts, the National Committee in Defense of Political Prisoners came to Pineville. This group was headed by writer Theodore Dreiser and included two other well-known authors—Sherwood Anderson and John Dos Passos.

The Dreiser committee was the result of a report prepared by members of the International Labor Defense that listed the injustices they saw being done to area coal miners. The committee based itself in Bell County at Pineville's Continental Hotel and ventured into neighboring Harlan to conduct interviews. Bell County officials greeted Dreiser and his fellow authors warmly but with some reserve. His stay in Pineville would prove memorable when he was indicted on charges of adultery.

Walter B. Smith, the Bell County attorney, and Herndon J. Evans, editor of the *Pineville Sun*, were both pro–mine operator and did not take very well to Dreiser and his committee. Smith and Evans, along with other townspeople, watched Dreiser's room at the hotel one night. His secretary, Maria Pergan, entered the room during the early evening hours. After she had gone into the room, Smith and Evans placed toothpicks against the door. When they checked the next morning the toothpicks were still in place, indicating that Pergan had spent the night in Dreiser's room. Dreiser's defense, which was probably not true, was that he had been impotent for over twenty years and therefore nothing adulterous had occurred in the room.

During Dreiser's stay in town, County Attorney Smith addressed a crowd in front of the courthouse dressed only in a pair of long johns—a union suit—that had been dyed bright red, saying that was the only color the Communists knew. Smith quickly changed into street clothes and

reappeared before the crowd to burn the long johns, much to the delight of onlookers.

The adultery charge was not the only one brought against Dreiser. Officials also charged him with criminal syndicalism, a legal term used to describe an individual's or group's use, or advocacy, of violence or terrorism as a means of bringing about economic or political change. The State of New York was asked to extradite Dreiser to stand trial on the criminal syndicalism charge, but he petitioned Governor Franklin D. Roosevelt for a hearing and the governor refused to sign the extradition order.

While visiting in Bell County, Dreiser and others met Jim Garland and his half sister, Aunt Molly Jackson. Both had been active in organizing the union, and the committee was much impressed by Jackson's recently composed song about the miners and their condition, "The Hungry Ragged Blues." Eventually, both Garland and Jackson would venture to New York, where they became involved with the NMU in that city, both helping to organize and composing and performing songs about east Kentucky. In time, they both followed other pursuits, but when the folk music revival came on the scene in the 1960s, they were much in demand as performers.

Garland, who had been forced to leave Bell County because of his union activities, is best known for his song "Welcome the Traveler Home," which contains the verses:

There's an old judge in Bell County,
His nose is big and long,
And the son-of-a-gun is awaiting
For to welcome the traveler home.

There's Walter B. Smith the attorney,
And he's got Gils and Combs
And the son-of-a-gun is awaiting
For to welcome the traveler home.

For all of its activities—soup kitchens and rallies—the NMU proved to be another failure for the miners who were seeking decent wages and living conditions. A rally in Pineville in 1932, in which 1,500 miners marched through the town, was the last big push of the union before it died out.

One miner was quoted as saying, "They didn't do what they said they would do…they promised they'd feed 'em and furnish 'em all the groceries they'd need—they came out on strike—and they didn't furnish 'em nothin', so they wouldn't have nothin' to do with it."

Working conditions would remain much the same throughout the 1930s—and beyond—until the UMWA returned.

THE DEPRESSION, A FEMALE SHERIFF AND CHAINING THE ROCK

O f course, the 1930s were not all mine accidents and union battles. Despite the Depression that cast a pall over most of the country, Bell Countians continued at their own pace for the most part—working when and where they could—and finding time for their other pursuits and avocations.

The decade started off with the appointment of the state's first female sheriff. Henry Broughton had served as Bell County sheriff since 1930 and died December 9, 1931, before his term expired. The sixty-one-year-old Broughton had been in politics for over twenty years, having served his first term as sheriff in 1897.

Upon Broughton's death, Judge George VanBever appointed Ellen Broughton, wife of the deceased sheriff, to serve until the next election, at which time a new sheriff would be chosen to complete the term. Mrs. Broughton was duly sworn in and operated the office much as it had been under her husband's tenure. In February 1932, she announced that she would run for election to the office in her own right. Mrs. Broughton did not win the election. She was defeated in the primary, and in the fall of 1934, James W. Ridings was elected to the office.

Mrs. Broughton holds the distinction of being the first female sheriff in the state, although that claim has been made for Pearl Carter Pace, who was elected in 1938 as sheriff of Cumberland County. Mrs. Pace was duly elected following her husband's term of office, as at that time a sheriff could not succeed himself. Although Mrs. Pace may have been the first *elected* female sheriff, she was beaten to the office by Mrs. Broughton, as the first *appointed* female sheriff, by some five years.

Sometime early in the decade Bertram Combs, son of Dr. Mason Combs, discovered a stone effigy of a man on Pine Mountain. The carving was found

in the vicinity of Fat Man's Misery, long a favored spot of hikers. Fat Man's Misery can be reached by following a trail up the face of the mountain above Catalpa Street in Pineville. The Misery is a narrow passageway between two huge stones.

Combs, then a teenager, took the effigy to his father's office. Dr. Combs in turn contacted the University of Kentucky and sent the carving there. The carving was of black stone, depicted a seated figure and is said to have been carved by early Native Americans who frequented the area in the days long before Boone or Dr. Walker. Over the course of years, the carving changed homes a few times and is now in the possession of the Heye Foundation Museum of the American Indian in New York City.

This stone carving bore an uncanny resemblance—according to contemporary reports—to a wooden effigy found in 1869 by a young Bell Countian named L. Farmer. The Farmer carving was of yellow pine and was also of a seated male figure. The exact location of the Farmer find is not known, all reports just stating that it was found on Pine Mountain. According to David Burns's *Gateway: Dr. Thomas Walker and the Opening of Kentucky*, the Farmer carving is in the possession of the Museum of the American Indian in Washington, D.C. His book features an excellent photograph of a replica of that carving made by Pineville native Lee Thomas Hopkins.

Other things were happening on Pine Mountain besides the locating of Indian effigies. For decades, the folklore of the area had been that a massive rock outcropping perched high above the Old Town section of the Narrows at Pineville was secured on the backside by massive chains that had been placed there by Native Americans. This tale supposedly came into being during the early days of the Wilderness Road, when some people, fearing it might fall, were afraid to pass along the road beneath the rock. The wagon masters and scouts who brought them through the wilderness concocted the stories of the chains to allay their fears.

After Cumberland Ford was settled, people still told of the "chained rock," and eventually tourists began asking about it. Townspeople could not show them a chain, so they told various stories—mostly that the chain was on the backside of the mountain.

Then, in the 1930s, a group of local civic club members decided to take the chain issue to hand. Their efforts turned into a publicity stunt reported in over six thousand daily newspapers nationwide and resulted in one of the area's best-known attractions.

According to information gathered by Pineville librarian Ron Day, in 1932 a couple from New Hampshire was visiting Pineville and asked to see the huge boulder that was perched above the city, held only by a chain.

The Depression, a Female Sheriff and Chaining the Rock

Workmen take a rest after stretching a chain from Pine Mountain to Chain Rock in order to "protect" the city of Pineville. The 101-foot chain was placed atop the mountain in response to a long-standing legend that Native Americans had chained the rock to prevent it from rolling down the mountainside and crushing the settlement below. *Author's collection.*

By chance they happened upon Pat Caton and a few fellow Kiwanis. They asked Caton why the chain could not be seen from the streets of Pineville. Caton told them that the chain had corroded away and that the city was in great danger should a tremor occur. The tourists quickly left town.

Caton and his fellow club members set about turning the old myth into a tourist attraction. They made a report to the Pineville Kiwanis Club and the club appointed a committee to find and install a chain. Headly Card was appointed chairman. The committee realized that its first task was to find a chain big enough to "hold the rock" and be seen from the city streets far below. Caton recalled seeing such a chain, part of an obsolete steam shovel, in Virginia. Inquiries were made and the result was that W.B. Paynter Sr. of Middlesboro donated the chain to the Chain Rock Club, as the committee was now known. The chain had been part of a Marion steam shovel owned by Paynter's Kentucky-Virginia Stone Company. The chain measured 101 feet in length and had three links to the foot, with each link weighing seven pounds.

The chain was transported by railroad flatcar to the foot of the mountain. It was cut into two sections and from there was moved by mule power. This

part of the job was managed by Arthur Asher and Thomas Hodd. Three or four mules, hitched in single file, began to pull half the chain up the steep mountainside. When the mules gave out, manpower was called upon. On the final trek to the top, the mules were assisted by Kiwanis, local Boy Scouts and members of the Civilian Conservation Corps. Once both halves were at the top, the chain was welded together and the arduous task of spanning the breach in the rock was begun.

That task is best described by W. Handley Gaddie in an article written some years after the fact. Gaddie was the manager of the Gaines Theatre and something of a showman, as evidenced by his account.

> *Brave men mounted to the top of the questionable rock and drilled with hammer and steel, a two inch hole four feet deep* [and] *inserted an…iron rod in the full length thereof; the rod having a sizable "eye" fixed on the exposed end where the chain was coupled, and then with a set of triple "Block and Tackle" ropes fastened on the other end of the long-big-chain, and together with 50 husky men and the spike team of mules harnessed with coal mine gears, they proceeded to tighten the chain just as tight as it was possible to do, and even at that there remains a sort of swag in the middle of the chain…and strange as it may seem, the two iron pins or rods were tamped into place with the use of Sulphur for this purpose, it being the better material to use than Babbit Metal or Solder. It had been a difficult thing to accomplish—it took all hands and the cook to do the job.*

Although there are conflicting dates, it seems that the task was finally completed on June 3, 1933. This group of men had accomplished two things. First, they had "secured" the rock and saved the town. Second, and most importantly, they had attracted the world's attention to the city of Pineville, which was their intent to begin with. Since the chaining was completed, hundreds of thousands of visitors have made their way to Pineville to see the Chained Rock. Those desiring a close-up look had to hike to the rock, uphill over a mile. This was improved in 1958 when Pine Mountain Resort State Park built a road to a parking area along the mountaintop, which allows a downhill stroll of only half a mile to visit the rock. Although the parking area and much of the trail is within the boundary of the state park, the rock and the chain themselves are on private property.

The version above is the official tale of the "Chaining of the Rock." Headley Card, however, in a conversation with the author in the early 1970s, told a slightly simplified version.

"It was the Depression," Card said. "We were all sittin' around the Court House Square one day—many out of work—looking for something to do. Somebody said, 'Let's put a chain on Chained Rock.' So…we did."

For a while, beginning in 1930, there was another community in the county that was the rival of Hensley's Settlement, as far as being self-contained and self-sufficient. Located in the Brownie's Creek area, across the valley from Hensley's Settlement, the community never had a formal name. It was referred to by its inhabitants as, simply, the Mountain.

Jim Cupp took his wife Caroline and fifteen of their eighteen children (three had died young) to Black Mountain on Kentucky 987, where he had leased the entire mountaintop from the Asher family for eighteen dollars per year. It was there that he planned to raise both crops and children.

Leland Cupp, one of the children, recalled that when they arrived on the mountain there was a single dwelling house already on the land. It consisted of two rooms joined by a large hall.

Another son, J.M., recalled, "They started out at Coldstone [another community near Brownie's Creek] and moved on the Mountain when Leland was six. I was born a year later."

The Cupps added a kitchen to the house that held a dining table $16\frac{1}{2}$ feet in length to accommodate the family, which grew to include twenty-one children (including a half brother)—seven girls and fourteen boys.

As the older children married and began families of their own, additional houses were built over the two-and-a-half-mile stretch of mountaintop. The community eventually grew to six houses in all, some of them a mile apart from the others.

The isolated community was maintained and worked by the entire Cupp family. They raised enough in the garden to feed themselves and their livestock and still had enough left for Jim to take to nearby mining camps to sell. "He sold stuff to buy the things we couldn't raise," J.M. said. Everyone worked on the Mountain, keeping the brush and briars cut back from the pastureland. Of course, getting in or out of the community was no mean feat. There was no road—just a path—so the only way to travel was by horse or mule.

The Cupp family stayed on the Mountain for ten years, until 1940, but while it lasted the little community was a thriving village unto itself.

The Roosevelt administration's alphabet agencies came to Bell County in the 1930s, as they did in other parts of the nation. One of the agencies, mentioned earlier in connection with the chaining of Chained Rock, was the Civilian Conservation Corps. The CCC established a camp on the Asher Mill Road, which runs parallel to the northern entrance (the Laurel Cove

entrance) of Pine Mountain State Resort Park. The camp was set up at what had been the County Poor Farm. The Poor Farm had operated at that site since the early 1900s and was relocated on Bill Green's property at Bird Branch, about two miles north on U.S. 119, when the CCC came in.

The CCC workers built fire trails throughout the mountains and helped with forest fires and reforestation. One of the "punishment" duties for workers at the Bell County Camp was to clean the old Settlers' Cemetery, which had been taken over by the Poor Farm. This cemetery is located just inside the mouth of the north entrance of the state park, on the right of the road, and was the land that Scott Partin recalled having been used by Union soldiers during the Civil War.

The WPA (Works Progress Administration) also became active in Bell County, building several public buildings and schools, as well as roads and bridges. The schools at Brownie's Creek and Cubbage, among others, were WPA projects, as was the Pineville Municipal Building.

The 1930s also saw the beginning of what has become a spring tradition known throughout the state—if not the nation and worldwide. The Kentucky Mountain Laurel Festival began in 1931 on the grounds of Clear Creek Springs. This annual event was the dream of Annie Walker Burns, historian and genealogist. Miss Burns was a distant relative of Dr. Thomas Walker and wanted to see an annual event in Kentucky to honor him. In 1930, she approached Governor Flem D. Sampson with her idea. The governor was supportive, and with the assistance of Bell County attorney Walter B. Smith, the event began to take shape.

By the spring of 1931, the Kentucky Mountain Laurel Festival had been born. Governor Sampson addressed the Pineville Kiwanis Club that spring, saying, "This section, southeastern Kentucky, has a monopoly on mountain laurel and rhododendron" and that people from all parts of Kentucky would come here to see it. He was making reference to Dr. Walker's journal entry that detailed the great profusion of mountain laurel he found at his first campsite on Clear Creek.

Governor Sampson had suggested that a pageant be held as part of the festival, with each college or university in the state sending a coed to compete for the title Mountain Laurel Festival Queen. This idea was readily accepted.

On Friday, June 5, 1931, the L&N ran a special train the three miles from Pineville to Clear Creek Springs to accommodate the festival attendees. The first event was set against a backdrop of magnolia and mountain laurel on a stage in front of Little Clear Creek. The University of Kentucky band provided the music for the pageant, and the young college girls from across

The Kentucky Mountain Laurel Festival, begun to honor Dr. Thomas Walker, has become a mainstay of spring events in Kentucky. The festival spans four days in late May and features a traditional outdoor beauty pageant. Pictured here is the queen and her court from the 1934 event. *Author's collection.*

the state curtseyed in front of a crowd of several thousand tourists and visitors. Governor Sampson placed the crown of mountain laurel on the head of the first Kentucky Mountain Laurel Festival Queen, Betty Ann Baxter, a native of Harlan County who was representing Eastern State Teacher's College (now Eastern Kentucky University). In his nervousness, the governor placed the crown backward on Miss Baxter's head, as may be seen in some photographs of the event.

On Friday night, the first Queen's Ball was held at the Pineville High School gymnasium. This was the first time that the Grand March was seen by a festival crowd, and it has become a featured attraction of the event. The Grand March, developed by Miss Nettie Hutchinson, is a serpentine procession in which the queen eventually emerges from an archway created by her court.

In 1933, the festival was moved to Laurel Cove Amphitheatre in Pine Mountain State Resort Park, as a road had finally been completed to that site. The following year, the first festival parade was slated for downtown Pineville.

Ironically, the festival started to honor Dr. Thomas Walker doesn't bear his name, and many of the yearly visitors to the event do not realize it is in his honor that they are gathered.

As the decade came to a close, another business destined to become a landmark opened in Pineville. Dr. J.S. Cornn began construction of the Bell Theatre in 1939, the second of Pineville's three movie houses. (The third, the Roaden Theatre, was built on Pine Street by the Reda family a few years later.) On the Kentucky Avenue section of the Court Square, the Bell was finished in Art Deco style with red, white, blue and silver trim accented by seven hundred linear feet of neon tubing. The theatre originally seated 304, with the very popular double seats at the end of every third row.

By the early 1960s, the theatre was suffering from low revenue, and the collapse of the ceiling during a showing of *Planet of the Apes* in 1969 forced its closing. Eventually, in the 1980s the theatre was completely renovated and restored to its original appearance by Downtown Pineville, Inc., and, until recently, continued as a first-run movie house.

BATTLE OF FORK RIDGE AND WORLD WAR

April 1941 saw one of the last major union gun battles in the area. It involved several men from Bell County, and at first there was some debate as to whether the actual gunplay occurred in Bell County or in Tennessee. Authorities eventually settled on Tennessee as the location.

On April 1, 1941, there was a shutdown at all mines in the area while negotiators of the United Mine Workers met with company owners in New York City to settle a contract. The mine of the Fork Ridge Coal and Coke Company, located in Tennessee just across the Kentucky-Tennessee border, had continued to operate despite the shutdown. Emotions were running high among union sympathizers, and trouble had been brewing at the mine for some days when it finally erupted in a full-scale war in the early morning hours of Tuesday, April 15.

The preceding evening, Bell County deputies Sterl Roberts and Harve Cross had been called to the state line on Kentucky 74 near the community of Fork Ridge when rumors of impending union trouble spread through Middlesborough.

Roberts told reporters at the time that C.W. Rhodes, president and general manager of Fork Ridge Coal and Coke Company, had asked the deputies to go up on the road and tell the pickets there that they were deputies and to ask them to keep the road open so the men working at the mine could get through when they left work. Apparently some of the first men to leave the mine that evening had started down the road to the Kentucky side and had seen the car lights of the pickets; they turned around and returned to the mine, prompting Rhodes's request.

Roberts walked along the road on the Kentucky side of the line to meet the pickets. He was first met by A.T. Pace, traveling auditor for the union group,

THE KNOXVILLE JOURNAL, WEDNESDAY, APRIL 16, 1941

Mine 'War' Fusillades Riddle Automobiles, Taking 4 Lives

Loyal workers of the Fork Ridge Mine congested during the day along the railway track at the company commissary to discuss details of yesterday's coal field battle at the Tennessee-

Kentucky line in which four men were slain and at least 13 others injured. The company office is shown in the far left background.

Lewis Allen, employe of the Rennebaum Coal mine near the scene of yesterday's clash at the Bell County, Ky., and Claiborne County, Tenn., line, points to a bullet-riddled state highway marker. One bullet hole in the wooden sign pointed directly to the scene of the slaying on the Tennessee side of the line.

Bob Robinson, slain early yesterday in the strike outburst on the Tennessee-Kentucky line, had been a colorful figure in this section for the past several years.

A resident of Tazewell, Robinson had served as sergeant in the Tennessee Highway Patrol. He was stationed in Knoxville until recently, when he was transferred to

ROBINSON Middle Tennessee, where he left the Patrol.

After his services with the Highway Patrol ended, he recently joined the miners, reportedly as a mine guard.

This sedan, owned by E. W. Silvers, one of the Fork Ridge Coal Co. officials slain along with three other men yesterday in the Middlesboro picket "war," was another of those struck by bullets during the exchange of gunfire. One bullet entered...

Spattered by bullets that plunged through the windshield door and window glass, this car owned by E. W. Silvers, Fork Ridge Mine Co. president, was a grim reminder of the day's predawn battle in which...

The last major union gun battle took place in 1941 at the Fork Ridge Mine. Four men were killed and eight wounded during the gunplay. *Author's collection.*

who asked what he was doing there. Then former Bell County sheriff J.W. Ridings come forward asking the same question. Ridings said to Roberts, "I wouldn't have thought this of you—you served under me when I was sheriff." Roberts replied, "Yes, but I thought as an officer I had a right to ask you not to violate the laws."

Ridings then asked Roberts to get into one of the cars, saying, "They [the picketers] are superstitious [*sic*] of you—you have a gun, don't you?" Roberts replied, "Yes," but still he did not get into the car, realizing how tense the crowd was and that shooting was apt to occur at any moment.

About then George Suttles, a Claiborne County, Tennessee deputy, came down the road in a car from the mine. Roberts said that some of the pickets were told to stop him to make sure he signed the check-off, a card authorizing mine owners to deduct union dues from a miner's wages.

When Suttles pulled his car to a stop, he was told to get out. He did, explaining that he was an officer and bringing a rifle and two pistols from the car with him. One of the pickets said to him, "You're in the wrong place."

Up at the mine, C.W. Rhodes, E.W. Silvers (vice-president and treasurer of the company) and Bob Robinson, a former Tennessee Highway Patrol sergeant, got into two cars, intending to move the pickets. A witness, Fred Pierce, overheard a voice from one of the cars saying, "I'll put them out of the way."

Those cars approached the pickets and were stopped to sign the check-off. When the cars stopped, three shots were fired from a clump of bushes on the Kentucky side of the state line, according to Sterl Roberts.

"Then the firing started all over," Roberts said. "Pace stepped in front of one of the cars to get around it out of range, and I stepped to the side and saw guns blazing everywhere. I knew I couldn't run out of their range."

Others recalled the first shots as coming from the Tennessee side of the line. Roscoe Sexton said that the door of Rhodes's car opened and a voice said, "Clear this road and get these cars out of here." Then three shots were fired from the Tennessee side of the line, according to Sexton. Fred Pierce also thought the first shots came from Tennessee.

Wherever they came from, all witnesses were in agreement that there were three initial shots. This was followed by a lengthier volley of gunfire, followed by a lull and then more rapid fire.

Sexton said that after the first three shots were fired there was "a burst of machine gun firing, then general shooting." Another witness, Bessie Wright, described the initial three shots, followed by a pause and then firing that "sounded like a package of firecrackers going off."

Sterl Roberts, who had remained on the road in the thick of the shooting, said:

> *The shooting eased up for a moment and I saw one man lying in the road and reached down and asked if he was hurt, and he said something about dying—I don't know which of the victims he was, because it was very dark. The firing became heavy again and I stepped between two cars, I heard bullets buzzing all around my feet under the car.*
>
> *After the shooting was over lights of the cars lit up two or three men lying in the road. I turned and met Jim Thacker, who suggested we walk down the road and get out of this mess and as we were changing our positions the pickets' cars began turning on the highway and driving away. Some of them picked up some of the wounded men, I suppose were picketers.*

The Battle of Fork Ridge, as the incident was quickly dubbed by newsmen, left C.W. Rhodes, E.W. Silvers, Bob Robinson and Sam Evans dead at the scene. Evans was one of the picketing miners.

Eight other men, all from Bell County, were wounded in the gun battle. They were, with descriptions of their wounds taken from a news report the day of the shooting:

R.W. Lawson, Field, shot through the upper left arm
Alford Smith, Rella, shot in the upper left leg and left foot
Walter Polly, Arjay, shotgun pellet wounds in the left side and arm
Earl Alley, Balkan, serious chest wound
John Holland, Cary, in serious condition from a wound in the right leg. His leg was amputated later that day
Clayton Webb, Capito, shot through the right hip
Millard Forester, Cary, shot through the upper left leg
A.J. Napier, Straight Creek, shot in the right knee

At first there was confusion as to who had jurisdiction in the shooting. Chief Bell County deputy sheriff Homer Green contended that the shooting had occurred in Kentucky, but Claiborne County deputy sheriff C.C. Harmon said that he believed the shooting was in Tennessee. Green argued that the first pool of blood was five yards on the Kentucky side of a marker that designated the state line. The wooden marker reading, "Enter Tennessee, Leave Kentucky," was riddled with bullet holes. Tennessee authorities claimed that the marker had been incorrectly placed originally and that it was about forty yards inside that state. Eventually, jurisdiction was established and it was agreed that the shooting had taken place in Tennessee.

Eight months after the shooting, the pickets involved in the incident went to trial in Tazewell, Tennessee, for the death of C.W. Rhodes. After deliberating five and a half minutes, the jury voted for acquittal.

The winds of war were blowing in Europe, and Bell County was preparing to face another boom. As with all wars, the need for manpower and materials would be great and the southeastern Kentucky coal fields would once more be called upon to provide fuel for the nation's war manufacturing needs.

Bell County would once more have to send forth its young men to fight on foreign soil. Of those who served, several paid the ultimate price. They were Bryant Belcher, Monroe Blackburn, Robert Blevins, Clyde Bowlin, James Bowman, Robert W. Brock, Emery Brooks, Sam Bull Jr., Harry C. Bush, John R. Cheek, Tom B. Clark, Delbert Cornelius, John S. Cornn Jr., Grover C. Dixon, James D. Douglas, Elmer Dunn Jr., Eugene Eastridge, Dan M. Fultz, Clyde E. Fuson, Robert T. George, Carl K. Gibson, James Gilbert, Varnie E. Godbey, Alvin D. Good, Floyd Goodin, Billy J. Gray, John R. Halbert, Walter R. Hampton, Clyde W. Harrell, Lawrence D. Haynes, Ambers P.

Hendrickson, Drexel E. Howard, Earnest Howard, Emmett Howard, George C. Howard, James E. Howard, Morrison Howard, Wadley C. Hunter, Clyde R. Jackson, Millard Jackson, Martin Jenkins, Ben D. Johnson, Ollie Johnson Jr., Hubert T. Jones, Claude Knuckles, Walter J. Knuckles, Press Lake, Perry Lee Jr., Elmer Lowe, Gordon Maples, Doyle Martin, Leonard F. Mason, David Massey, Silas McCreary, Kenneth McKiddy, Orville McNew, Milace H. Miller, Tom Mills, Eugene H. Owens, Welford Oxford, Ancil Partin, Joe E. Pearl, William E. Phillips, Henry C. Phipps, Ira Pierce, Thomas Poore, Herman Price, Craig Ralston Jr., Woodrow Reed, Charles Rhodes Jr., Acey T. Saylor, Sewell E. Sharpe, Lodus Shoffner, Estil Smith, Lloyd E. Smith, Pearl Smith, Richard Smith, Bruce A. Sowder, William J. Sowder, Johnny P. Stewart, Jessie A. Summers, Everett Thacker, Ray J. Thacker, Ernest Thompson, Otis Thompson, Robert B. Thompson, Burgess Townes, Jim Turner, Frank E. Turpin, Luther Ward, Luria J. Watson, Nealy T. Wease, Shirley West, William H. Whitaker, Glenn White, Charles Whitefield, James L. Williams, Justus R. Wilson and Hobert Wright.

Although all of Bell County's young men served well and with distinction in World War II, there were two who placed themselves above the mark. One rose to fame in death as the county's only Congressional Medal of Honor recipient; the other achieved notoriety by becoming the modern U.S. Navy's only "peg-legged" admiral.

Leonard F. Mason, a native of Middlesborough, was a private with the Second Battalion, Third Marines, Third Marine Division, during the war. Near the end of the conflict, in 1944, Mason was severely wounded in battle on the island of Guam. Subsequently dying from his wounds, he was posthumously awarded the Congressional Medal of Honor for his courageous actions in battle. Fighting on Guam continued through August 10 before U.S. forces completely captured the island, at a cost of 1,484 marines and 591 infantrymen killed.

The "peg-legged" admiral was Pineville native John Madison Hoskins. Hoskins was the son of Pineville's first mayor and had been serving with the U.S. Navy since 1921. He had graduated from Annapolis 300th out of a class of 300, but was to eventually rise to the rank of rear admiral. As a young ensign, he had struck up an acquaintance with Charles Lindbergh when his ship brought Lindy and the *Spirit of St. Louis* back to the states following their successful trans-Atlantic flight.

By the time of the Second World War, Hoskins was a captain and was preparing to take command of the light carrier the USS *Princeton*. The change in command was to take place just as soon as the Battle of Leyte Gulf ended. Hoskins could have elected to sit out the battle and then take

U.S. Navy Rear Admiral John M. Hoskins, a native of Pineville, lost a leg during World War II but continued his naval career as the "modern navy's only peg-leg admiral." *U.S. Navy photo.*

command of his ship, but he opted to stay onboard during the fight to learn as much as he could about his coming duties.

On October 24, 1944, two days after his forty-sixth birthday, Captain Hoskins was on deck of the *Princeton* when a Japanese dive bomber dropped a five-hundred-pound bomb through the hangar deck. Hoskins, who technically was a passenger aboard ship, could have been evacuated with the flyers and technicians who were removed from the ship in order to "fight another day." But something in his pioneer background kept him onboard—after all, this was to be his ship—to help direct the firefighting crews.

Hoskins was about midships on the smoking flight deck when fires spread into the bomb magazine below. A terrific blast dazed him and threw him to the decks. When he tried to stand, he fell over; his right leg felt numb. When he looked down he saw that his foot was missing both shoe and sock—and was attached to his leg by only a small sliver of flesh just above his ankle.

As Hoskins was evacuated from the now sinking ship, his litter was passed through the crowd of sailors he was to have commanded. "I'm sorry boys," he told them. "I was going to try to make you a good skipper."

Hoskins was flown to the Naval Hospital in Philadelphia. Along the way, he recalled the navy's position on one-legged commanding officers: there was no use for them; there were too many hale and hardy men available, all clamoring for commands at sea. But Hoskins was determined to regain his

command. His favorite phrase to all he told about his plan to get back to sea was, "You just watch me!"

In due time, he was fitted with an artificial leg, which he gamely set about learning to use. Six months after he was wounded, he walked out of the hospital without the aid of crutch or cane. He then took on his plan to command a ship with a renewed fervor. He persuaded higher-ups to slate him for command of a new carrier if he passed the necessary physical examinations. With arduous and bone-tiring training, he passed the physical. True to its word, the U.S. Naval Department gave him his carrier—he was to command the new USS *Princeton*.

Hoskins continued his naval career throughout that war and the next. As a rear admiral, he led the Seventh Fleet to Okinawa in preparation for the first naval strike of the Korean War and he launched for the first time in naval history a navy jet aircraft from the deck of a carrier against hostile forces in Korea. Hoskins became interested in air evacuation for the wounded and later commanded the Pacific Division Military Air Transport Service.

Among his many decorations over a long and distinguished career were the Navy Cross, the Distinguished Service Medal, the Army Silver Star, Legion of Merit, the Purple Heart and the Order of Military Merit from the Philippine government. Hoskins died in 1964 and is buried in Arlington National Cemetery.

Admiral Hoskins's exploits during and after the Battle of Leyte Gulf were depicted in a film by Republic Pictures in 1955. Starring Sterling Hayden, *The Eternal Sea* had its Kentucky premiere at the Bell Theatre in Pineville at the 1955 Kentucky Mountain Laurel Festival.

The Eternal Sea. Sterling Hayden (right) played Pineville, Kentucky native John Hoskins in the biopic of his life. *Publicity still by Republic Pictures.*

After the war, Bell County's servicemen and women again returned to their native lands. Many went back to work in the mines, but a large number began the out-migration that was—and continues to a lesser degree—to plague the area.

One sight that greeted returning servicemen and women was the mural at the Pineville Post Office. Another project of the Roosevelt New Deal programs, this painting was done by Edward Fern as part of the Treasury Department's Section of Painting and Sculpture (later Fine Arts), generally referred to as the Section. A lot of people mistake the artworks under this program as being done by artists on relief; this was not the case. The artists had to submit designs and ideas to a committee and a commission for the work of art—whether it be a painting or a sculpture—was awarded. The confusion persists because the WPA featured a similar program, the Federal Art Project, which aided artists already on relief. Between 1934 and 1942, the Section commissioned murals and sculptures for federal buildings and for 1,100 post offices nationwide.

Fern arrived in Pineville in 1942 to complete his commission—*Kentucky Mountain Mail en Route*. The painting depicts a postal carrier on horseback fording a stream to deliver mail to a young woman who has anxiously waded into the water. On her hip she carries a young child. On the opposite bank, another young woman waits to hand him a letter.

The oil on canvas painting came under much criticism while Fern was painting it and afterward. Herndon Evans of the *Pineville Sun* centered his front-page editorial on criticism of government spending on art during wartime. He also said that the painting looked like something from "out west" rather than a Kentucky scene.

Reverend J.A. McCord, who was postmaster at the time, replied to Evans's editorial. "The artist told me he got the idea for this picture in Lee County, Ky. The name on the letter being delivered is Miss Joyce Hamilton, Delvintia, Ky."

McCord seems to have been one of a handful of postmasters throughout the country who were not adverse to the Section's murals. Many of the problems arose because the artists produced designs that had appeal to the national panel making the selections rather than to the people of the area in which the artwork was to be displayed. Occasionally there would be a problem because the artist would be awarded a site other than that for which he had created the design.

Fern, a native of Cincinnati, Ohio, completed his commission in Pineville and moved on, but he left behind an enduring piece of art that has become a part of Bell County history.

TRAGEDY AND DISASTER

The mid-1940s proved to be both sad and catastrophic years for Bell County; 1945 ended with a tragedy and 1946 began with a disaster.

The day after Christmas 1945, the miners at the Belva-Straight Creek No. 1 Mine at Fourmile had just returned to work following the holiday. There was a small crew that day, many opting not to go to work after the preceding day's celebrations.

Sometime between 8:00 and 9:00 a.m., the mine was ripped by a horrendous explosion that trapped inside, deep within the bowels of the earth, thirty-one men who just a few minutes before had cheerfully entered the mine following their Christmas holiday.

Rescue operations were begun immediately by mine owner Bill Lewis. Men and safety crews from throughout the coal fields were called for, and they worked straight around the clock for the next three days, fighting underground fires, digging out debris and shoring up charred and sagging timbers in a frenzied effort to locate the thirty-one men trapped below.

Families remained huddled around small fires near the driftmouth through the day and that night, awaiting word from underground. Finally, just a short while after dawn on the second day, news came from the still burning mine. Bad news. Some of the men had been found, but they were dead. Officials presumed that all thirty one had suffered the same fate, but rescue operations continued.

Although many of those waiting outside the mine had given up hope, they continued to wait, more or less resigned to hearing that their loved ones were among the dead. Then, almost fifty-three hours after the blast had swept the mine, good news began to circulate among those waiting. Nine men had been found alive. The wait, and speculation as to who had survived, went on as rescue workers prepared to bring the nine men to the surface.

UNITED MINE WORKERS JOURNAL

VOL. LIX, No. 21

NOVEMBER 1, 1948

Tragic Aftermath of Kentucky Mine Disaster

Scene at Kentucky Straight Creek Mine, Four Mile, Ky., during the recovery of the bodies of 20 explosion victims entombed in the mine for nearly three years.

One of the worst mine explosions in Bell County's history was at Belva-Straight Creek Mine at Fourmile. Twenty miners were entombed for three years before officials deemed the mine safe enough to recover the bodies. *Author's collection.*

First to be resurrected was Al Bennett. But as the stretcher bearing him passed through the crowd, it was seen that he was completely covered. He had died just as he was brought to the surface. The eight remaining men were brought out and taken to Pineville Community Hospital. They were McKinley Leath, Ivan Philpot, Huey Miller, Tom McQueen, Charles Lingar, Joe Hatfield, Bud Townes and Bill Branstutter.

After the nine were brought out, officials of the Kentucky Department of Mines made the decision to seal the mine to allow the underground fires to burn themselves out. In addition to the survivors, two bodies had been recovered, leaving twenty men entombed in the mine that was to become a temporary mass grave. Left underground were John Brock, George Matthews, Frank Mills, Hugh Westerfield, Jim Bain, Bill Carroll, Jim Tom Gambrell, Jim Tom Fisher, Harmon Lovell, Delbert Lockard, Bill Brock, John H. Branstutter, Dave Sharp, H. Reed Lawson, Jim Emery, Bud Partin, Floyd Gambrell, Jim Collins, Champ Patterson and Henry Honeycutt.

The survivors credited Bud Townes with saving their lives. Townes had survived the 1930 explosion at the Pioneer Mine at Kettle Island and knew what needed to be done if the men were to live through the ordeal. Taking charge, Townes directed the erection of a barricade across the opening of a side room. Once everyone was inside, he scrawled on a piece of slate, "Nine miners in here. 11 a.m. Thursday." He then crawled through the opening and sealed the hole from the inside. Directing the men to the farthest corner of the room, Townes scratched arrows on the mine wall to show the way they had gone; he knew that when rescuers eventually came they would follow these signs and arrows. Some men had their lunch pails and some water, which Townes rationed over the next fifty-three hours.

Because of Townes's foresight, the men survived their ordeal, and when they arrived at the hospital in Pineville seven of the survivors refused to be separated from Townes. At the time the hospital was segregated and Townes was an African American. His fellow miners refused to let him be placed in the "Colored Ward," insisting that they all remain in one ward. Hospital officials gave in to their demands and, in effect, the hospital was desegregated that day, years before it became a national law.

Joe Hatfield Sr., one of the eight who came out alive, told a reporter for the Chicago *Sun-Times*,

> We had a pretty fair intake of air; and we had food and water. There were sandwiches in three lunchboxes, but black damp had turned them green in spots. We cut off the spots and ate the rest. We just lay quiet. Bud said too much exertion was bad. I guess it was. I started crawling around and the

black damp raised up and knocked me out. Somebody shoved me and I was
O.K. again. That was funny, wasn't it?

Black damp is a carbon dioxide mixture that occurs as a mine gas and is incapable of supporting life or fire.

The twenty men left inside Belva-Straight Creek No. 1 Mine remained there for nearly three years, together in death as they had been in life—side by side in the deep, dark bowels of their workplace. Through repeated appeals from family members and urging of officials of the United Mine Workers of America, the mine was finally unsealed and the task of removing the bodies began, some thirty-two months after their entombment. Finally, fifteen of the dead were removed from the mine on October 18, and the remaining five bodies were recovered on October 20 and 21, two years, nine months and twenty-five days after they were entombed. Positive identification was made through lamp numbers, car checks and personal belongings.

Not all of the victims were killed instantaneously; at least four of them lived for several hours after the blast, until they were overcome by the deadly afterdamp. Fifty-year-old Jim Bain was found on his knees beside his final written words, "God bless us all is my prayer." Another miner had written, "Dear God. 3:30 o'clock…O.K."

Prior to the removal of the bodies, mine owner Bill Lewis had reached a settlement with widows of fourteen of the miners who had sued him. The settlement came to $2,000 each. He also agreed, voluntarily, to pay the same amount to ten widows who had not been party to the lawsuit. In addition, a settlement for $2,000 each was reached with six of the survivors who had sued for $11,500 each and one widow who had sued for $15,000. The settlements were paid with an initial payment of $200 for each claimant, followed by $48 monthly installments on the balance.

After the bodies were removed, the mine was inspected by federal and state officials. In a report following the investigation, A.D. Sisk, director of the Kentucky Department of Mines, announced that he had "eliminated all theories except the smoking angle," stating that a match had been found near one of the bodies. However, Taylor Maddox, safety director of District 19 of the United Mine Workers of America, disagreed, blaming the mine management, citing safety inspections by the Kentucky Department of Mines made shortly before the explosion that read, "Nothing is being done toward safety and mine law is being absolutely neglected in every respect." Maddox also said that interrogation of several witnesses revealed that the main fan had been shut off for over five days during the Christmas holiday, allowing gas to build up in the mine.

While much of the county was recovering from the shock of the lives lost at Fourmile, a natural tragedy struck. Always prone to flooding, the Cumberland River and its tributaries overflowed their banks in January 1946, less than two weeks after the accident at Fourmile. The rains had been coming down steadily for two days and flood stages all along the Cumberland River from Harlan County on down were being reached—and surpassed.

When the rains finally stopped on January 6, the flood was at its zenith and water was five to six feet deep in most homes in the downtown area. Stores were flooded, their plate-glass windows broken by fast-traveling motorboats.

It was the worst flood of record that Bell County had experienced, topping the infamous 1929 flood by two feet. In the court square area, it almost reached the first floor of the courthouse.

Durham Howard recalled the 1946 flood in an interview in the 1960s:

> *Now I had an office up the street in the '46 flood…And when it got six feet in my office and I sat on the Continental Hotel porch* [at the corner of Virginia Avenue and Walnut Street] *where I had waded to get to a place where I could rest and talked to a TVA engineer—well a member of the Corps of Engineers—and we were just sitting there the next day, looking at that water flowing through the town, almost up to the court house. And he told me, "When you look at the maps of this area and the tremendous watershed that you have got, with the narrow valleys that you have, that river could get over the top of that court house."*

Paul Greene also recalled the flood, writing,

> *As I recall, the floodwater began to cover the floor in our home* [the Greene Apartments, behind the First United Methodist Church on Oak Street] *about 8 p.m. We retreated upstairs and waited for the inevitable…The next morning I stood at the top of our steps and looked at the dismal view below. The water stood 60 inches deep in our home. Turning to a view from the upstairs window I could see the post office and Ward McGaffey on the roof looking over the very dismal and depressing scene.*

Another Pinevillian who had vivid memories of the 1946 flood was Minnie Price. Although her home was on Cypress Street and remained out of reach of the river water, she had several memories of the flood and its aftermath. Interviewed for the County Oral History Project, she told the interviewer,

Honey, we woke up one morning and the water was comin' up. It was raining and we thought it was gonna get up; didn't think it was gonna get that high. I said to Ed, Wake up, get up. I believe I hear a lot of cars or somethin'. He looked out and said, Well, gosh, I guess you do. The hill's lined with cars. Water's all down here in the road. What road? Down on the highway. They had a little store right down there where Paul Wilson's is [at the corner of old U.S. 25E and Maple Street]. *He said go down there.* [The next few sentences on the tape were unintelligible.] *There was a woman settin' right at my steps in a car. I had put the coffee on. When I come back up they said, the children said, That's Minnie! Hi, Minnie! She said, Lord, I smell your coffee. She said can I have a cup? I said, Why Lord, yeah. Come on. We had killed hogs and I had fried up a lot of sausage and canned—we'd put it up in cans…But, anyhow, I couldn't turn them children down. I give 'em a biscuit and sausage. And that's what started the people comin' here. The town was—water was all over town. My husband had to go down to the KU and I said you get you some boots if you can find 'em down there. He went on. Finally, Honey, he got this boat and come back. Water was everywhere. At the Continental Hotel they set up a Red Cross canteen. Well, old Dr. Brooks* [Dr. James M. Brooks Jr.] *was the mayor here. Well, we'd fed and we'd fixed 'til we's about to run out of something to eat ourself. Dr. Brooks come up here and asked me about openin' a canteen. I said, A canteen? Ain't you got one downtown? He said, Yeah, but that water's comin' in that hotel. Later on the Red Cross pulled up their canteen and come up here, and Honey, our house was full. These KU men came and then the man said to me, Can you take care of these KU men and care for 'em? They've got to work. I said, Well, I'll try. Old Dr. Brooks—he's the mayor—he said, Now Minnie, if you'll do that we'll pay for what of your food you use. 'Round the mountain to Middlesborough the road was high. So, a crate of eggs…I don't know, bacon I guess and bread. I had plenty of pintos to cook for 'em, and cabbage. Honey, me and my husband cooked I forget how many meals. A hundred or two a day. Chil', I'd hear these KU men comin' in from work, you know. I had a long fish fryer. I put it on the stove and got it hot. I'd fry the bacon and when I'd hear that truck pullin' up out there I'd start to breakin' eggs. I tell you I couldn't do it now; I's a younger woman. That's in '46. We took care of 'em. Akers* [Ray Akers] *that works for the KU—lives up here at Straight Creek—tells me now, How we laid up in Minnie's floor, over behind the heater—had a Warm Morning coal heater out there in the hall—they'd come in and fall down behind that, they's so tired and wet. They said when they'd wake up I'd have a pillow under their*

heads. Long after that we had to take care of 'em, cause it went in all the restaurants...the hotels. Upstairs at the school; went in that office upstairs. There's circles up there today, on the wall there. Honey that was a time.

The severity of the 1946 flood spurred local politicians and civic leaders to pursue a course of action for flood protection for the city of Pineville. Mayor T.R. Ware (who succeeded Mayor Brooks), former mayor Brooks, Handley Gaddie, Representative A.J. May and Representative James S. Golden Sr. worked with the federal government and the U.S. Army Corps of Engineers to devise a flood control system for the town. Among the options studied were dams along the Cumberland River and Clear Creek, diversion channels and a protective floodwall. The floodwall option won out, but work on the project did not begin until federal funds were appropriated in 1952. By early 1955, about half of the concrete wall, which followed the old river road around the town, around the central part of town was completed. In 1956, the northern end of the wall, to the Pine Street bridge, was finished. By 1957, the entire project, including the earth levy around Wallsend, was completed and most Pinevillians breathed a sigh of relief. They were now protected from the rampages of the Cumberland...or so they thought.

ON TO FAME AND FORTUNE

During the 1940s, three Bell Countians made their way out into the world to pursue their careers, far removed from the usual pursuits of logging or mining that they found at home.

The first of these was Charles Conant Queener. Born in Pineville in 1923, Queener spent his early years in Bell County. Later, his family moved to Knoxville, Tennessee, but he returned to Pineville each year to spend the summer months visiting his grandparents.

In her youth, Queener's mother, Gladys, had aspirations of becoming an opera singer, and her musical bent was passed to her son. Graduating high school at the age of sixteen, Charlie attended the University of Tennessee. At that time, UT did not have a musical program, and Queener showed little interest in the school until he joined a campus band—Dick Jones and His Collegians. He then became acquainted with some members of Jimmy Dorsey's band when they played a date in Knoxville; when the Dorsey band left town, Charlie went with them. He was eighteen years old.

Marian McPartland, host of Public Radio's *Piano Jazz*, recalled seeing Queener in 1946. "I came over here [from England] in 1946," she said. "Jimmy [her husband, trumpeter Jimmy McPartland] took me to Eddie Conden's [a noted jazz club]. Queener was playing there. He was a very nice guy. He was always cordial to me when we met," McPartland said. "He worked with my husband…quite a bit in the late '40s and early '50s. He was well known in jazz circles; a very, very good player."

Because of his quiet, unassuming nature, he began to be known in jazz circles as "Quiet Queener." Queener's career continued through the 1980s while he interspersed his performing with composing orchestral works. He

died at Englewood, New Jersey, where he had made his home for several years, at the age of seventy-five on February 25, 1997.

Another Pinevillian who was to travel the world in pursuit of his career was William Preston Slusher—known professionally as Preston the Magician and Hypnotist. Slusher was the son of W.P. and Fannie Slusher, who operated a small store on Pine Street in Pineville in the 1930s and 1940s.

Preston developed his interest in magic while a student at Pineville City Schools, and by the time he was in high school he was regularly performing around the area. At first he sent away for simple magic tricks and after he mastered them he became interested in stage hypnotism. It was eventually added to his stage act.

By 1941, Preston's career was put on hold during World War II. While serving with the United States Army Air Corps, he performed for various military shows and was chosen to entertain at the reception in Washington, D.C., when General "Hap" Arnold was promoted to five-star general.

Although a world-class performer and traveler, Preston kept close ties with Bell County, returning to the area every year to visit and perform. Preston and his wife, the former Mildred Fuson, also of Pineville, maintained a residence in Pineville. They kept an apartment in the basement floor of an apartment building they owned on Walnut Street. Mildred, as much the showman as Preston, dubbed the apartment "The Penthouse—Upside Down."

Preston was a natural choice to serve as general manager of the Kentucky Mountain Theater when Professor Orlin Corey's religious drama, *The Book of Job*, began its successful twenty-year run at Pine Mountain State Park. Preston would tour during the winter months and return to Pineville to manage the theatre and production during the summer.

Preston made his home in Florida with his second wife, Jean Wild, whom he married following Mildred's death in 1987, during his later years, but he continued to perform...and to return to Bell County quite often. During 1980, he served as president of the International Brotherhood of Magicians. Preston the Magician and Hypnotist died April 17, 1994, and is buried in the Pineville Cemetery.

If you mention the Cigarette Trick to most people, they know immediately that you are referring to another Bell County native Jim Tom Williams. Williams is the son of Reverend John and Patsy Williams and was born in a small house on Log Mountain just south of Pineville in 1925. Known worldwide as the Great Carazini, Williams began his interest in magic at an early age but did not develop the trick for which he is best known until his days in the United States Army in World War II. Stationed in the Pacific during the war, Carazini had the opportunity to see several magicians and to develop his own act.

Pineville native Preston Slusher (standing on chair) became known worldwide as Preston the Magician and Hypnotist. Here he is shown with Babe Ruth assisting in his act early in his career. *Courtesy of Phillip Slusher.*

"I guess it was the excitement of friends that started me [in magic]," Carazini said. "I'd do a little trick and they'd get excited. When I was in the army I'd throw checkers up in the air and then tell a guy to look in his pocket…the checkers would be there. I saw one guy do a trick with a cigarette—but not like I do."

The famous Cigarette Trick involves Carazini standing alone onstage, dressed in a black suit and shirt, wearing a black slouch hat. He proceeds to roll a cigarette from a package of tobacco. He then lights it…and then lights the other end as well. Rolling his eyes, he finally decides that the cigarette will make a tasty snack—so he eats it, fire and all! For the next several minutes he feigns indigestion, thumping his chest and belching billowing clouds of smoke. All the while rolling his eyes in seeming distress, Carazini, at strategic points, gags, beats his chest and blows sparks from his nostrils. Eventually the smoke fades and he then discovers that he has somehow managed to swallow a long string of multicolored silks, which he proceeds to pull from his mouth. When the silks have been dealt with, it seems that the smoke is starting to appear again. But no, instead of a smoke cloud forming at his lips, Carazini emits a series of a dozen or more ping-pong balls that apparently have been swallowed at some earlier time. He keeps producing ping-pong balls until his exit music leads him from the stage.

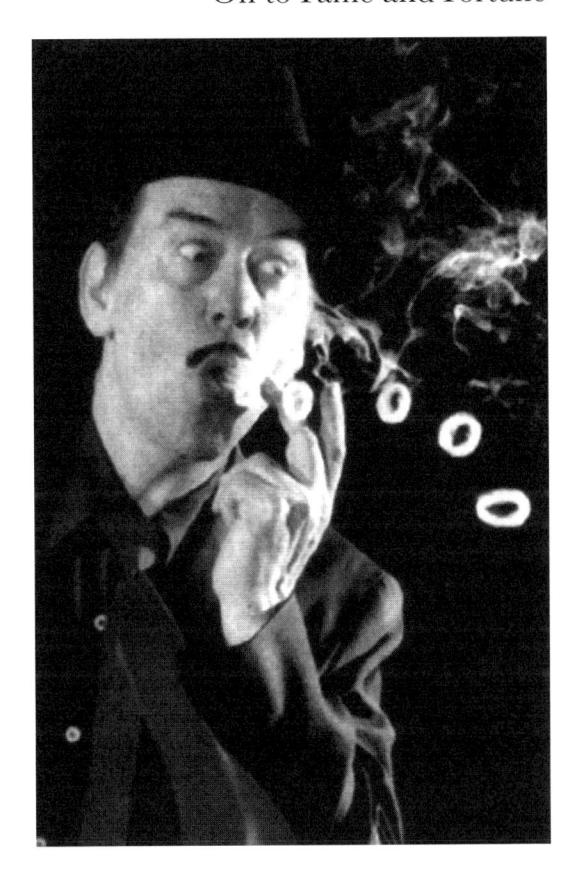

Jim Tom Williams, better known professionally as the Great Carazini, perfected a magic act in which he "ate" lighted cigarettes and then produced smoke rings. Williams's career has taken him from the streets of Pineville to the boulevards of Paris. *Author's collection.*

Anyone who has seen his act can quickly tell you that the written word does not adequately do justice to Carazini's performance; however, it does give one an idea of the trick he is best known for.

The first time Carazini performed the Cigarette Trick professionally was while still in the army in 1942. His magic of choice is sleight of hand, a form of magic still dear to him. "There's plenty of magic without going into these big boxes and flashes," he says.

Carazini's career has carried him far from Log Mountain; he has appeared on several national television programs, making five appearances on *The Tonight Show with Johnny Carson*. His longest run at any one spot was at the famed Crazy Horse in Paris, France a ten-year stay.

Carazini, falling into ill health in recent years, is a patient at a local skilled nursing facility.

RADIO STATIONS AND NATIONAL PARK

A lthough it was not at the peak it had seen during the war years, the coal industry was holding firm with mines operating throughout the area. The outmigration of young people and returning veterans had not hurt the industry as much as some feared, and with the coming of strip mining in a few years coal was headed toward another boom.

But first Bell County again sent its young men off to war. The United States entered the Korean War in June 1953. Those from Bell County who died in the war were Asher Daniel, Glen Elsworth Frazier, William Frederick, Herschel E. Fuson, Robert L. Green, Wilburn Helton, Howard R. Jeffery, Bill Ed Johnson, Alvis D. Lawson, James D. Lee, James L. Mason, John R. McCoy, Chester Rice, Roy L. Smith, Eugene R. Thompson, Martin W. Warren and James D. Welch.

Radio came to Bell County during this period. Around the end of World War II, radio station WMIK, then at 1490 on the dial, was opened by Maurice Henry in Middlesborough. Not long afterward, another Middlesborough station, WCPM, began broadcasting at 560 mhz. Henry soon purchased WCPM. He moved WMIK to the then better frequency of 560 mhz and stopped broadcasting on 1490.

By 1957, a third station joined the airwaves of Bell County. South C. Bevins came to Pineville from Lexington, Kentucky, at the request of Charlie Trivett to begin operating station WMLF at 1230 on the AM dial. WMLF's first broadcast was at noon, March 10, 1957, according to Bevins. Bevins said that the station remained in operation as WMLF until 1970, when the call letters were changed to WANO to tie in with the nationwide move to phonetically pronounce the call letters of a station. Where the old call letters had stood for Wonderful Mountain Laurel Festival, the new designation did

not stand for anything—they are just a combination of letters that can be pronounced as a name.

Since the first radio station began in the 1940s, the county has seen the addition of WRIL-FM (originally WTJM) in Pineville and WFXY-AM, WMIK-FM and WXJB-FM in Middlesborough.

Tourism continued to play a role in the area, and by 1955, the National Park Service took over a project that had been developing south of Middlesborough. The first mention of preserving the Cumberland Gap and surrounding areas as a park was made in the 1890s, but it was never really pursued. Then, in the 1920s, a bill was introduced to authorize the park, but it was not passed until 1940.

Acquisition of the land—some twenty thousand acres, making the park the largest of all National Historical Parks—was slow, spanning nearly two decades. This task was spearheaded by Howard Douglas and Tom Fugate of Middlesborough and involved a number of condemnation suits. One such suit had 107 defendants.

In 1955, the National Park Service stepped in and things began to move a little faster—roads, displays and the visitors' center off U.S. 25E just outside of Middlesborough were built. A road had been cut to the Pinnacle Overlook in 1929, and this Skyline Drive was now improved to accommodate more visitors. The long-range goal of the Park Service was to restore the saddle of the gap to what it had been when Boone first crossed it.

The work was eventually completed and the Cumberland Gap National Historical Park was officially dedicated July 4, 1959, in ceremonies attended by then Vice President Richard M. Nixon. Other dignitaries present were Senator John Sherman Cooper, Senator Estes Kefauver, Lieutenant Governor Wilson Wyatt, Congressman John Robinson Jr., Congressman W.H. Jennings, Senator Thruston Morton and Governor Bert T. Combs. Harry Hoe of Middlesborough was chairman of the dedication committee.

The park is visited by thousands of tourists each year and the main historical displays emphasize the four periods of Cumberland Gap history: the prehistoric and Indian period; the pioneer and migration period; the Civil War period; and the industrial boom of the 1890s. Other points of interest in the park are the restored Hensley Settlement, Cudjo's Cave, the three-states marker (where Kentucky, Virginia and Tennessee meet, making it possible to stand in three states at once), a restored section of the Wilderness Road and the remains of Civil War entrenchments and rifle pits.

As Pineville is the "City Under the Rock," Middlesborough became the "City Under the Cross" about 1950, adding another attraction to the area. The cross is directly in line with the main thoroughfare of Middlesborough,

at the east end of Cumberland Avenue. It is made up of a string of large lights shaped like a traditional cross. These lights are suspended about ten feet off the ground and this gives the illusion that the cross—which can only be viewed at night—is floating over the town. It can be seen as one drives west to east along the avenue and is visible for a distance of about two miles.

The Lighted Cross was devised by a man whose life was devoted to crosses, Henry Harrison Mayes. Mayes erected the cross about 1950 and for a number of years maintained it and paid the utility bill himself, with the occasional donation from local residents. As Mayes's health deteriorated, Johnny Morrison took on the task of keeping the cross maintained. When Morrison died in 1983, the upkeep of the cross fell to his son, J.R., who still keeps the cross lit each night, rain or shine.

One major change in the education field took place in the 1950s. In 1957, the Lone Jack Independent School District, which served the area around Fourmile, north of Pineville, merged with the Bell County School System. Lone Jack High School had served the area since 1927; a need for a high school was seen as early as 1924, but the State Department of Education had rejected the early plans for the school.

When Lone Jack became part of the county system, a new elementary school was constructed on old U.S. 25E to serve the community, and students were brought to Lone Jack by bus from many parts of the county. This school served for several years until Lone Jack High School was consolidated in 1983 with the New Bell County High School—which combined Old Bell High and Lone Jack—in modern facilities on Log Mountain, south of Pineville. The high school at Henderson Settlement had been consolidated with Bell County High School some years before, and now there was only one school serving the students in grades nine through twelve.

BROADFORM DEEDS
AND STRIP MINING

T he biggest change to face the coal industry was the coming of strip mining in the 1950s and its relationship to the broadform deed. From the 1890s through the 1910s, when holding companies were purchasing mineral rights in Bell County and in other parts of the state, the broadform deed was the most used instrument for these rights. It derives its name from the complex, inclusive language it features. Broadform deeds give the purchasers the rights to all minerals under the ground.

In essence, the broadform deed gave the purchaser of mineral rights a free hand to remove the coal underneath the surface in any method he saw fit, even if it meant the destruction of buildings and the surface itself. At the time these mineral rights were purchased, strip mining was not a normal method of producing coal. Instead, most mining was by the deep pit method.

As technology improved in the 1950s, strip mining became more prevalent, much to the dismay of some landowners and environmentalists. The broadform deeds signed by a landholder's father or grandfather often allowed companies to come in and strip land without the permission of the landowner—and without compensation for damages. Often mountaintops were sheared off, hollows filled in and working farms used for storage of mining equipment. Landowners were often denied access to their property.

Environmentalists were concerned because of the danger of flooding caused by strip mining in some areas as well as the increased water pollution in some streams. As early as 1947, some legislators saw the problems that might be encountered by strip mining and began to lobby for legislation to provide reclamation of the land.

These efforts paid off, and by 1966, the state legislature adopted the most stringent reclamation law in the nation. In 1977, when the federal Surface

This is a section of strip-mined land at Mountain Drive Coal Company on Brownie's Creek after it has been reclaimed. Kentucky adopted strict reclamation laws in 1966, which were later adapted into the federal laws of the 1970s. *Courtesy Olard Hickman.*

Mining Control and Reclamation Act was adopted, it included many of the provisions first set forth in the Kentucky law.

In the 1950s, many landowners began filing lawsuits to stop coal operators from using the broadform deed to strip mine. But Kentucky courts were vehement in protecting the rights of these deeds. By 1956, the court of appeals had upheld the right of the mineral owner in a number of cases, thereby upholding the right of the contract specified by the deeds.

Landowners in the late 1800s sold their mineral rights for as little as ten cents an acre, according to some sources. The mine operators, however, dispute that figure. They aver that some of the earliest deeds were purchased for three dollars an acre and in some cases the surface rights were purchased at an additional two dollars an acre, which would have been a fair price at the time the deeds were written.

Attempts were made in the state legislature throughout the 1970s to limit the use of broadform deeds, and in 1988 an amendment to the state constitution was finally approved that requires the consent of the landowner before surface mining can occur.

Broadform deeds and the associated woes notwithstanding, the coming of strip mining proved to be another boom for the area, and eastern Kentucky saw the making of many "overnight millionaires" thanks to the surface mining methods. Mines were prevalent throughout the county well into the 1970s, and wages were once again at their highest, adding to the general economy and again bringing the trickle-down effect to other local businesses.

RHODES, YEARY AND *JOB*

Among the Bell Countians who left the area in the 1950s to pursue their dreams and careers, two have risen to prominence in their selected fields.

The first of these was Betty Jean Rhodes. Raised at Straight Creek, Rhodes was a graduate of Bell County High School and was well known in a small circle of churches in the area as she sang for different services and funerals with her sisters. She left Bell County in 1953, headed for Washington, D.C., to begin a career in the fingerprint section of the Federal Bureau of Investigation.

While in Washington, she met and married Harry Robinson, and it is as Betty Jean Robinson that she is known worldwide today. Harry Robinson eventually accepted a job in Nashville, Tennessee, and he and his young wife and daughter moved there.

One day an acquaintance of Porter Wagoner heard one of her songs and told the country star about it. Wagoner liked her songs and voice and offered to take her songs to Chet Atkins at RCA records. Atkins felt that they weren't "hit" material, although he did tell Wagoner that he thought Robinson was capable of producing a hit and he was interested in her future output.

One thing led to another and Betty Jean became a songwriter in Nashville. She produced material recorded by various artists, including Connie Smith, Johnny Cash, George Morgan and Hank Snow. One of the songs she wrote for Snow, "Hello, Love," can be heard weekly as the theme song for Garrison Keillor's *Prairie Home Companion* on National Public Radio. Other country titles she wrote included "Red Rose from the Blue Side of Town" and "Baby's Back Again."

By 1974, Betty Jean was named Top Female Songwriter of the Year by *Billboard* magazine. Yet, with a successful career and top accolades bestowed upon her, Robinson says she began to feel like something was missing from her life. She had achieved many goals, but not happiness.

Robinson eventually returned to the religious roots she had developed as child in Bell County. She turned from writing and performing country songs to writing and performing gospel songs. Robinson was introduced to Christian television programming by Jim and Tammy Bakker of the *Praise the Lord* Christian talk show. This led to a more widespread audience for her, and while touring a few years later, she met Paul and Jan Crouch of Trinity Broadcasting Network, who gave her the opportunity to produce and sing on her own show, *Up on Melody Mountain*.

Robinson now resides in Brentwood, Tennessee, and travels throughout the world as a musical evangelist, yet she still keeps in touch with her roots, returning several times throughout the years to visit with old friends and family. She came back to Bell County a number of times to sing at funerals of people she had known as a child and as a young teenager.

The other Bell Countian who "made the big time" hails from Middlesborough, where he grew up as Harvey Lee Yeary. Yeary was born in Wyandotte, Michigan, but when his parents died in separate accidents while he was still an infant he was adopted by his aunt and uncle, Mildred and Harvey Yeary of Middlesborough.

Lee grew up in Middlesborough and became a football standout for the Middlesboro Yellow Jackets in the mid-1950s. Graduating high school in 1957, he attended the University of Indiana and Eastern Kentucky University, hoping to make a career of football, or in the athletics field.

While at EKU, he married Kathy Robinson and they had a son, Lee II, born in 1962. Kathy and Lee decided to try out for a production at the Pioneer Playhouse in Danville, Kentucky. When they both won roles in *7 Husbands*, Lee changed directions, deciding to pursue acting as a career.

The couple moved to Los Angeles, and when Lee decided he would need a professional name for his acting career, he kept his own middle name—Lee—and took the name Majors for a last name. The Majors name was in recognition of one of his college football coaches, Johnny Majors.

As Lee Majors, he won his first film role, a brief appearance in 1964's *Straight Jacket* starring Joan Crawford. It was a short part—his character was killed in the first five minutes of the film—but it was a start and his acting career began to move upward. He began appearing in various television anthology shows, and in 1964 he got his first television break. He won the role of Heath on *The Big Valley*, starring Barbara Stanwick.

About this time, he and Kathy divorced and she returned to Kentucky with their son. In 1968, Majors met Farrah Fawcett and began dating her in earnest; they eventually wed in 1973.

Meanwhile, his career kept climbing. After a successful five-year run in *The Big Valley*, he appeared in two other series—*The Men from Shiloh* and *Owen Marshall, Counselor at Law*—before getting the biggest break of his career. In 1973, he accepted the role of Colonel Steve Austin in a movie of the week called *The Six Million Dollar Man*. This TV movie became a series and catapulted Majors to mega-stardom. *The Six Million Dollar Man* lasted for five seasons.

In 1981, Majors returned to television with another successful series, *The Fall Guy*, and in 1982 he and Farrah Fawcett divorced, having been separated for a number of years. He married Karen Velez, a former Playmate of the Year, in 1988 and they have a daughter, Nikki Loren, and twin boys, Dane Luke and Trey Kulley. They divorced in 1994 and he began a relationship with Faith Noell in 1995. They presently live in Fort Lauderdale, Florida. Following *The Fall Guy*, Majors has made guest appearances on various TV series and has made a number of large-screen movies.

Lee Majors has maintained his ties to Middlesborough since his career began, returning often to visit his family. Usually he would slip quietly into town and out again before anyone knew he had been "home." On one memorable visit in the early 1960s, he brought with him Rock Hudson, who proved to be the hit of several private receptions held in their honor.

In the 1980s, following a contribution by Majors to the Middlesboro schools, which made renovation of the football field and stadium possible, the field was renamed the Lee Majors Field at Bradner Stadium.

Talent and theatrics is a two-way street in Bell County; not all of it left the area—some was imported at mid-century.

The shofar first echoed from the surrounding hills in Pine Mountain State Resort Park's Laurel Cove Amphitheatre in the summer of 1959; *The Book of Job* was presented for the first night of its twenty-season run. A biblical drama based on the book of the same name, *The Book of Job* was adapted for the stage by Professor Orlin Corey.

The Kentucky Mountain Theater contracted with Corey and his Everyman Players to produce the play in Pine Mountain as an outdoor drama at the time that such productions were becoming popular around the country. Preston Slusher was chosen to act as manager for the theatre company, and the production settled in to what would become a long run, bringing tourists from across the nation to the area to see the unique drama. On any given night, one could find cars in the parking lot from as far away as California, Maine and Florida.

Lee Majors, a native of Middlesborough, Kentucky, brought screen legend Rock Hudson with him when he visited his hometown in the 1960s. From left are Hudson, Althea Robertson, Majors and Oscar Robertson. *Author's collection.*

The Book of Job, which remained true to the text of the King James version of the scripture, featured a Greek chorus of antagonists who taunted Job for remaining true in his belief. Each evening during July and August, the shofar—or ram's horn—would sound in the pitch blackness of the amphitheatre. Then, as the lights slowly came up, a voice could be heard calling, "Jo-o-ob! Jo-o-ob!" Once the stage was fully lit, there was revealed one of the most unique makeup and costume schemes of the time. Each actor or actress was fully made up as a living mosaic! The mosaic concept was designed by Corey's wife, Irene Corey, a well-known costumer in her own right.

Many of the cast for the production came from the Actor's Theater of Louisville and the Louisville Children's Theater, and during some summers they presented various productions each Saturday morning geared toward a younger audience. For these plays they drew on nursery rhymes and children's stories.

A publicity still of an early cast of *The Book of Job*. The play enjoyed a twenty-year run in Pine Mountain State Park Amphitheatre. *Author's collection.*

Professor Corey also adapted another religious drama, *Romans by St. Paul*, and occasionally it was played for a week or so each summer as an alternative to *Job*.

The Book of Job received international attention and appeared in several magazines such as *Look* and *Life*. It was taken to New York a number of times during the course of its twenty-year stay at Pine Mountain.

FLOOD AND FLOODWALL

Although Pineville was protected by a floodwall, there had been a few times since its completion in 1957 when local residents feared that the water might once again get into the town. These were close calls, but still the town felt pretty much secure in the knowledge that the wall had served well during past floods.

Then, in 1977, the worst fears of the small town were realized.

The rains had been coming down steadily for a couple of days and the Cumberland River was already out of its banks on the morning of April 4. Throughout the day, those inside the wall watched the river with a wary eye as it continued to creep upward, at first to the base of the wall. Then, after the floodgates were in place, halfway up the concrete barrier…three-quarters of the way up…a few inches from the top…

As 11:00 p.m. approached, most knew that it would just be a matter of time before the muddy waters of the Cumberland spilled into the town. Those who lived in the lower parts of town had already taken refuge with family or friends on higher ground; those who did not know anyone on the hillsides simply sat in their cars parked along the streets. Some had loaded their possessions into large trucks and had them parked on high ground, but most had nowhere to take their belongings and were left in houses that were quickly abandoned. A few had foreseen the danger before the floodgates had closed and had managed to get out of town and to dry ground in Middlesborough.

At 11:30 p.m., the water began to come over the wall. The floodwall worked as designed and the water "backed into town," breaking over the wall on the downstream end first. This design was so that the town would not feel the full force of the current that would have been present had the water broken over on the upstream side.

Floodwaters nearly destroyed the city of Pineville in 1977. In this view of the courthouse, the water level is halfway up the doors leading into the building. The floodwaters reached a depth of twenty feet in the downtown area. *Photo by John G. Howard.*

One of the first clues that the water was coming over the wall was the pumps blowing out at the Ball Park Pump Station. The floodwall had pump stations located at strategic spots to pump surface water over the wall and back into the river; when the river itself came over the wall, the pumps could not take the strain and blew up.

By daybreak on April 5, the worst had been realized; the downtown area was inundated by twenty feet of water.

The wall that had served well for two decades now proved to be a nemesis in that it did not let the floodwater escape as the river returned to its banks. Instead, the water stayed in town for several more hours as it seeped out through the overburdened storm drains.

Most of the area within the wall was accessible by April 6 and residents began the task of returning to their homes—or what was left of them—to see if they could be salvaged. Some were fortunate; their homes received only five or six feet of water. Others were completely overtopped and in some cases the houses had been moved from their foundations. Everywhere one looked there were inches of thick, gooey mud left as the waters receded.

Cleanup would prove to be a problem at first; the water supply was limited and the stores that sold cleaning supplies—mops, brooms, squeegees and

shovels—had themselves been destroyed by the waters. Food, too, was a problem. The residents on the hillside had managed to feed many of those left stranded, but their supplies had run low as well.

The American Red Cross, the Salvation Army and the Bell County Rescue Squad were quick to respond to the disaster, and soon foodstuffs and cleaning supplies were pouring into the town from all over the state and, eventually, the nation.

The National Guard was called in by the governor, and local mining companies lent their equipment to aid in removing debris and the mounds of mud. But, as for the homeowners, they were faced with the task of cleaning their homes alone—at least until the national media broadcast news of the disaster. Then relief teams from churches nationwide poured into town to help as many as they could. As one observer put it, "The flood made equals out of everyone. There was no rich or poor. Bank presidents worked alongside the common day laborer."

During this period, the local arms of government were not inactive. Mayor Andy Williams began the task of coordinating the efforts of all the relief agencies as well as the multitude of federal agencies that were coming into the area. Bell County judge Willie Hendrickson assumed this same task for the county. Water, gas, electricity, communications, medical services—all of the niceties of day-to-day living—had to be rebuilt, and the enormous task was pursued by factions from all local governments.

Shovel by shovel, the mud and debris was cleared over a period of months, and as time passed some residents began to find humor in some of the things that had occurred. One family described finding their refrigerator turned upside down when they returned home. As they began the task of cleaning up, they noticed that the collection of magnets that had adorned the refrigerator was gone. They assumed that they were lost in the mud now being hauled from their home so they dismissed any further thoughts of the magnets. A day or so later, when the lady of the house opened a closet, she found the magnets—all neatly lined up on the metal clothes rod, placed there by the river water!

Another resident, who lived on higher ground, allowed his front yard to be used as a landing area for boats while the water was at its highest. He said that about two o'clock in the morning a boat pulled up, manned by three men in white rain gear. He invited them in for a cup of coffee to "warm up," assuming that they were with one of the local rescue groups. Once in the kitchen, he started getting coffee cups out when he noticed one of the men eyeing a bottle of bourbon on the counter. "Do you want a drink instead?" he asked. The reply was affirmative and he turned around to get some glasses. When he

turned back, the man was just taking the bottle down from his lips following a long swig. The homeowner, stammering, said, "Uh—uh—you fellows with the rescue people?" "Nope," came the reply as the bottle went back to his mouth. "We're from the Forestry Camp [the local minimum-security prison camp in Chenoa, Kentucky] and that's the first drink I've had in five years!"

Still another bit of whimsy was the tale one local man told of moving to the upstairs of his home as the water entered the front door. "I had my rod and reel up there and while my wife and I sat on the top step we'd see something float by that we'd forgotten to 'save.' So I'd cast and drag it in."

Pineville's theme following the flood was "We Shall Rise." And rise it did, with the aid of men like Mayor Bob Madon, who succeeded Andy Williams, Dr. James S. Golden, Steve Cawood, James O. Roan and many, many others. Madon took over the reins of mayor at a critical time and the task was an enormous one, but with a love for his hometown equaled by none, he set about restoring Pineville.

Many meetings were held and many plans were discussed, but the end result was that, through the efforts of Mayors Williams and Madon, various state senators and congressmen, Dr. Golden, Roan and Cawood, assisted by hundreds of others, a new floodwall and highway design was proposed and approved.

The battle for this new flood protection was a long one and entailed hours, days and weeks of lobbying. Madon at one point corralled then Speaker of the House Tip O'Neill at a Washington restaurant to tell him of Pineville's plight.

Finally, by 1983, construction of the floodwall—designed to withstand a five-hundred-year flood as opposed to the one-hundred-year flood rating of the old wall—was begun. Incorporated in the design is a concrete barrier around the "main" portion of town and a higher earthen levy and concrete wall around Wallsend. Just inside the main wall is a four-lane section of U.S. 25E, which had long been lobbied for. The project was completed in 1990 and the new section of roadway was named the Robert L. Madon Bypass in recognition of his work on the project and his dedication to the city of Pineville. Total cost of the project was $67 million.

But in a sense the cost was much greater, for by saving itself, the city of Pineville had to lose quite a bit—over 130 homes and businesses were razed to make way for the project.

CLOSING THE TWENTIETH CENTURY

From 1970 until the close of the twentieth century, Bell County saw many changes; some good, some bad…some still undecided.

On the Pineville side of the county, in the early part of the '70s the old Continental Hotel, once a showplace, had fallen into disrepair and was torn down to make way for a municipal parking lot. This parking lot eventually gave way to the Total Care Medical Building and its aspirations of bringing shoppers back to downtown. The people did come—for medical service, but not to shop as had been hoped for. Another landmark hotel—the Pineville—had been converted into an apartment hotel in the late 1950s and was eventually razed in the 1960s to make room for an auto dealership display lot.

The mound on Pine Street was razed to make way for a commercial building. During this construction, the remains of a grave from the Civil War were found. It had been the grave of S. Pipher, Forty-ninth Indiana Infantry, who was killed during a skirmish on nearby Breastwork Hill on June 18, 1862. It was determined that the grave had been disturbed once previously, when the Hodge house was built atop the mound. At that time, Dr. Hodge removed Pipher's skeleton and reassembled it for use in his medical practice. It was subsequently passed to Dr. James S. Golden of Pineville.

The old J.J. Gibson home on the site of the original Shelby/Renfro House opposite the Cumberland Ford was torn down and the property was turned into the Woodward Mini-Park. All that remains of the original site are the unmarked graves of three slaves who apparently belonged to the Renfro family.

The courthouse was being renovated when the 1977 flood struck the town, but the project was completed on schedule, providing quarters for the

This tombstone from the Civil War was found in the Indian mound on Pine Street in Pineville when the mound was excavated in the 1970s. *Author's collection.*

new court system. Under the new judicial system, the county judge and the magistrates no longer held judicial powers; they became administrators, and the judiciary system was handed to the newly created district court. The first judge of Bell District Court was Kelly T. Clore, a prominent attorney in Bell County. He held the office until his death in the 1980s.

In the outlying areas of the county, mining was still prominent but by the late 1980s it had lost much of its "boom" quality. No longer were "millionaires made overnight," and many of those employed by some of the bigger out-of-state mining concerns left the area for operations in western states.

On the Middlesborough side of the county, concern was being voiced over the dangers of Cumberland Mountain. Over the years, "Massacre Mountain," as it came to be called, had claimed many lives as fast-moving modern vehicles traveled the mountain's narrow, steep roadway.

Also in Middlesborough there was concern over the output of the Middlesboro Tanning Company's waste products. This hotly debated controversy placed three groups at odds—the City of Middlesborough, the Middlesboro Tanning Company and a group of concerned citizens dubbed the Yellow Creek Concerned Citizens. The Concerned Citizens and the Environmental Protection Agency claimed that Yellow Creek was at times heavily polluted by the output from the tannery, which had replaced its natural dyes with a chrome tanning process in the 1960s. The city came into its share of blame when it was claimed that the sewage treatment plant was not capable of handling the waste from the tannery. Over several years, many suits and countersuits were filed. The Yellow Creek Concerned Citizens claimed that the pollution in the creek—the largest stream in the county after the Cumberland River—had killed several farm animals and had contaminated wells of some of the nearly 1,200 residents who live along the creek.

In the mid-'70s, Bell County welcomed its native sons home from the Vietnam War. On May 7, 1975, President Gerald Ford declared the "Vietnam Era" officially closed. Those from Bell County who died during that war were Arnold Lee Brock, Lorenza Gayles, Bobby Ray Hatfield, Thomas Junior Lawson, James Allen Miner, James Miracle Jr., Wince Isaac Overton Jr., Ronnie Ray Pitman, Thomas G. Richmond, Jimmy Henry Rowlett, Danny R. Simpson, Harold Sullivan, Alonzo Allen Teague, Dan Wagner Jr., Charles Edward Ward and Homer West.

The closing years of the century saw much progress in some areas and sadness and disappointment in others, followed by triumphs of both public and personal scope. The educational systems of all the schools were heavily revamped under the Kentucky Education Reform Act (KERA) and all three school systems in the county readily adapted to these new policies.

The Bell County School System was ready for the challenge with a new, ultramodern facility on Log Mountain that incorporated Old Bell High and Lone Jack High Schools as one. Across U.S. 25E, the system built a new middle school and heavily revamped many of the elementary schools in the

rest of the county, with a completely new structure being built for the Lone Jack Elementary School.

The Pineville Independent School System, which had held classes in trailers for several years following the 1977 flood, built a new building at its site on Virginia Avenue. The new facility connects the elementary building and the old high school building and gymnasium and is designed with computer-oriented classes and the "pod-system" of teaching in mind.

The Middlesboro Independent Schools completed a central auditorium and arts center in the 1990s to house a variety of programs ranging from the visual arts to the ROTC program. Earlier, the system had restructured its other schools to prepare for KERA.

Also in Middlesborough, the 1980s brought about the first Cumberland Mountain Fall Festival. This festival, now in its twentieth year, was originally promoted in the downtown area and reflected the city's English heritage. It has since grown in scope and is now located on the campus of Southeast Community College in Middlesborough and draws tourists from throughout the region each fall for a weekend of entertainment, crafts, antiques and much more.

The 1980s saw a first for city government in Pineville. Longtime mayor Robert L. Madon, who had guided the town through the aftermath of the devastating 1977 flood, was forced to resign from office after being indicted and found guilty of misuse of city funds; he was the first mayor to be tried while in office. Madon had served as mayor since 1978 and stepped down in 1987. He was succeeded by his son, Scott Madon, for one term. The senior Madon was reelected in 1993, having been granted a full pardon by Governor Wallace Wilkinson. Madon reassumed the chores as head of city government with most of his political savvy, charisma and zeal for the town still intact. He remained in the mayor's seat as a popular political figure, devoting his energies to bringing business back to the area and making the downtown a viable shopping area once again, until he retired in 2002.

The 1990s saw the culmination of several movements to improve the safety of travelers across Massacre Mountain. The federal government, in cooperation with the States of Kentucky, Tennessee and Virginia, completed a twin-bore tunnel through Cumberland Mountain to carry four lanes of U.S. 25E, thus eliminating the climb over the steep incline along the old, narrow roadway. This echoed the plans of the 1800s to place a tunnel in the mountain to carry water-going vessels through a series of locks and canals.

With the mile-long tunnels in place, the old road through the gap was no longer needed and this property reverted to the National Park Service. The gap and the surrounding mountainside are at present being "returned

to their natural contours, much as they were in the days of Daniel Boone," which completes one of the original goals of Cumberland Gap National Historical Park—to preserve the history of Cumberland Gap.

When the Gulf War—Operation Desert Storm—began in June 1990, Bell County once again had some of its native sons and daughters fighting on foreign soil. The Gulf War, the start of which was witnessed on television, was a brief one, and no lives of Bell Countians were lost in the battles.

In 1992, a piece of history was recovered from beneath the Greenland ice cap by an expedition headed by Middlesborough entrepreneur Roy Shoffner. During World War II eight planes—six P-38s and two B-17s—were forced to land on the ice cap because of bad weather. The twenty-five crewmembers were rescued, but the aircraft were left behind. Fifty years later, the expedition led by Shoffner uncovered one of the P-38s from beneath 268 feet of snow and ice buildup. The plane, dubbed "Glacier Girl," was brought to the Middlesboro–Bell County Airport and restoration work was begun. "Glacier Girl" has been completely restored using authentic parts and made its first flight in over sixty years in October 2002.

Bell County government experienced a "first" in 1999 with the election of its first female judge-executive. Bell County native Jennifer Lefevers Jones was elected to fill the county's highest office. She served until 2002.

In just a few short years, Bell County will be two hundred years old. Much has happened since Dr. Thomas Walker first crossed the gap into the Yellow Creek Valley, and undoubtedly there is more to come as it moves beyond Boone and Bell…

BIBLIOGRAPHY

Adcock, Jason. "The National Miners Union."

Asher, A Family History. Bell County, KY: 2000.

Asher, Charles. *The Appalachian Home Journal*. Louisville, KY: 2001.

A Backward Glance magazine

The Bell County Story, The Unfolding of a Century. N.p.: Sun Publishing Company, 1967.

Burns, David M. *Gateway: Dr. Thomas Walker & the Opening of Kentucky*. N.p.: Bell County Historical Society, 2000.

Chicago Sun-Times

Combs, Robert Mason Osborne. *Memoirs as I Drew, Painted and Remembered*. Pineville, KY: 1997.

Coomes, Kay. "History of the Kentucky Mountain Laurel Festival."

Cornett, Tim. *Images of America—Bell County*. Charleston, SC: Arcadia Publishing, 2002.

Crawford, Byron. *Kentucky Stories*. New York: Turner Publishing Company, 1994.

DeRosett, Lou. *Middlesborough, the First Century*. N.p.: Action Printing Ltd., 1988.

Fuson, H.H. *History of Bell County, Vols. I & II*. New York: Hobson Book Press, 1947.

Garland, Jim. *Welcome the Traveler Home*. Lexington: University of Kentucky Press, 1983.

Greene, Paul F. *Just Rambling* series, 1970s–80s.

Halsey, Ashley, Jr. Untitled essay about Captain John M. Hoskins, circa 1944.

History & Families, Bell County, Kentucky. N.p.: Bell County Historical Society, 1994.

Kincaid, Robert L. *The Wilderness Road*. Middlesboro, KY: 1972. Originally published by Bobbs-Merrill Company, 1948.

Kleber, John E., ed. *The Kentucky Encyclopedia*. Lexington: University of Kentucky Press, 1992.

Knox Countian

Knoxville Journal

Knoxville News-Sentinel

Linton, Calvin D., PhD, ed. *American Headlines Year-by-Year*. N.p.: Thomas Nelson Publishers, 1977.

Mayes, Clyde. *Pictorial History of Middlesboro and the American Association Land Companies in Mingo Hollow*. Middlesborough, KY: 2000.

Middlesboro Daily News

Morgan, Earl. *Unforgettable Memories*. Edited by Marie Morgan. N.p.: 1994.

Nash, Jay Robert. *Almanac of World Crime*. N.p.: Bonanza Books, 1996. Originally published by Anchor Press/Doubleday, 1981.

Partin, Ben. *The Good Old Days, Recollections of a Boy from the Mountains of Northern Tennessee*. N.p.: Alliance, 1999.

Peters, Jennifer. "The 'Bloody Harlan' Years in Kentucky and Their Historical Context."

Pineville, Kentucky. Promotional booklet by Pine Mountain Iron and Coal Company, 1888.

Pineville Sun

Robinson, Betty Jean. *Up on Melody Mountain*. Lake Mary, FL: Creation House, 1997.

Rorrer, Katie. "Prepare to Meet Thy God: War in the Harlan County Coal Fields."

Tipton, J.C. *The Cumberland Coal Field and Its Creators*. N.p.: Pinnacle Printery, 1905. Reprinted 1997 by Conley Bingham, Middlesborough, KY.

United Mine Workers Journal 59, no. 21 (November 1, 1948).

"The Unofficial Lee Majors Page." www.fortunecity.com/lavender/shaft/24/bio/index.htm.

ABOUT THE AUTHOR

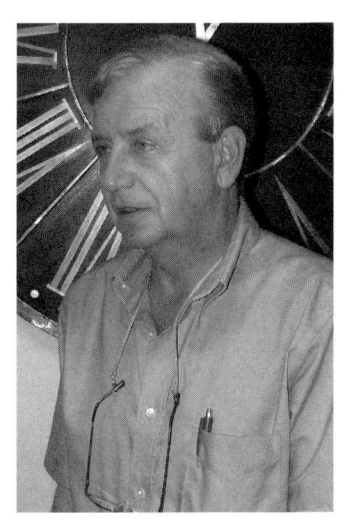

Courtesy of Vicki Dye.

Pineville, Kentucky native Tim Cornett has spent much of his adult life delving into the history of Bell County, Kentucky, and the surrounding region. In addition to his avocation as an amateur historian, he has been employed as a reporter, photographer, news editor, managing editor, florist, history magazine publisher and editor, public relations director and a local government employee.

He is currently single and has two adult daughters, Shauna and Kari. He lives in his childhood home in Pineville, where he still maintains an avid interest in local history.

Visit us at
www.historypress.net